iNSiDe FLoZBoX

SKeTCHeS & DooDLeS BY ToBiN FLoRio

© 2015 Tobin Florio. All rights reserved. ISBN 978 - 1 - 326 - 46620 - 6

Music is a major influence in my work, my inspiration, and my joy, which I try to give back in the only way I know how.

I love to lose myself in sound and feel a need to translate the experience into a visual format. I try to capture the atmosphere of the places I go to in my mind, give form to the emotions aroused in me and let the energy of the music direct a sense of movement through use of colour and composition.

Often the text in my drawings and paintings are song lyrics or titles of the tunes, which set the mood of the piece, though usually they are written in code as the text primarily serves a decorative purpose.

Live music events are an excellent source of inspiration, though of a different kind, as here we can witness the visual, physical presence the artist brings to their sound. In this case, I usually just like to try and capture the moment by making a sketch either there and then, or a day or two later while the experience is still fresh in my mind.

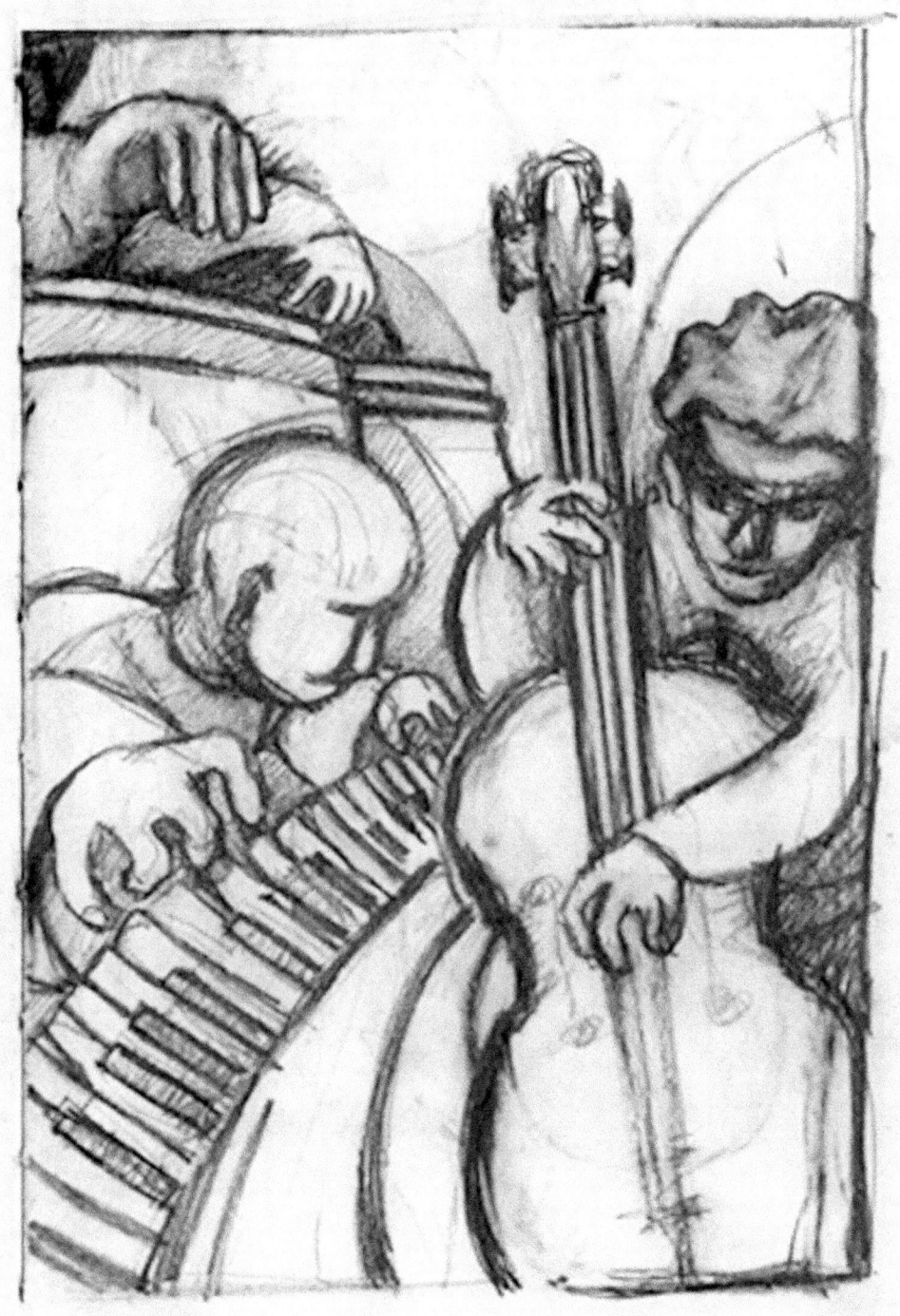

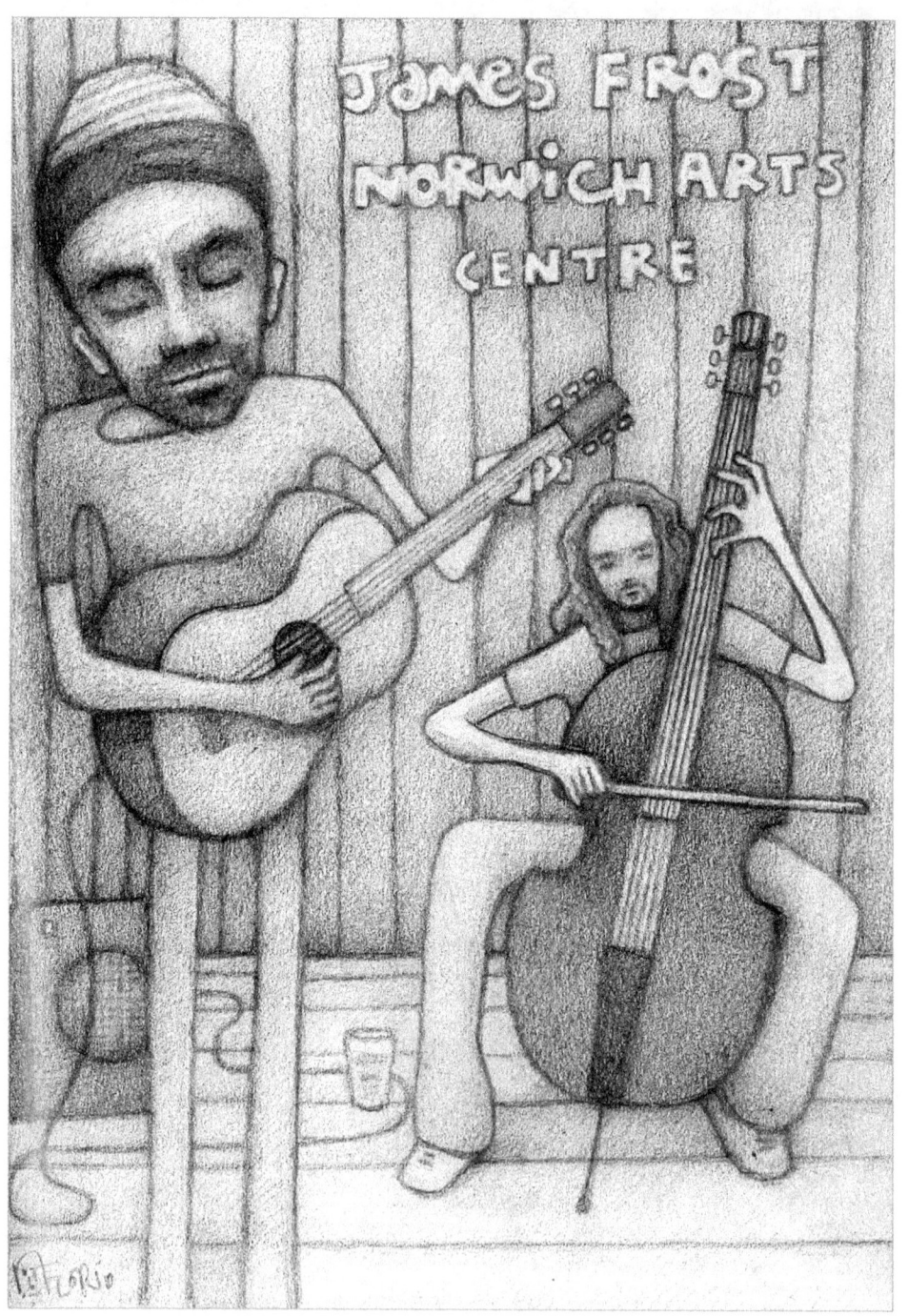

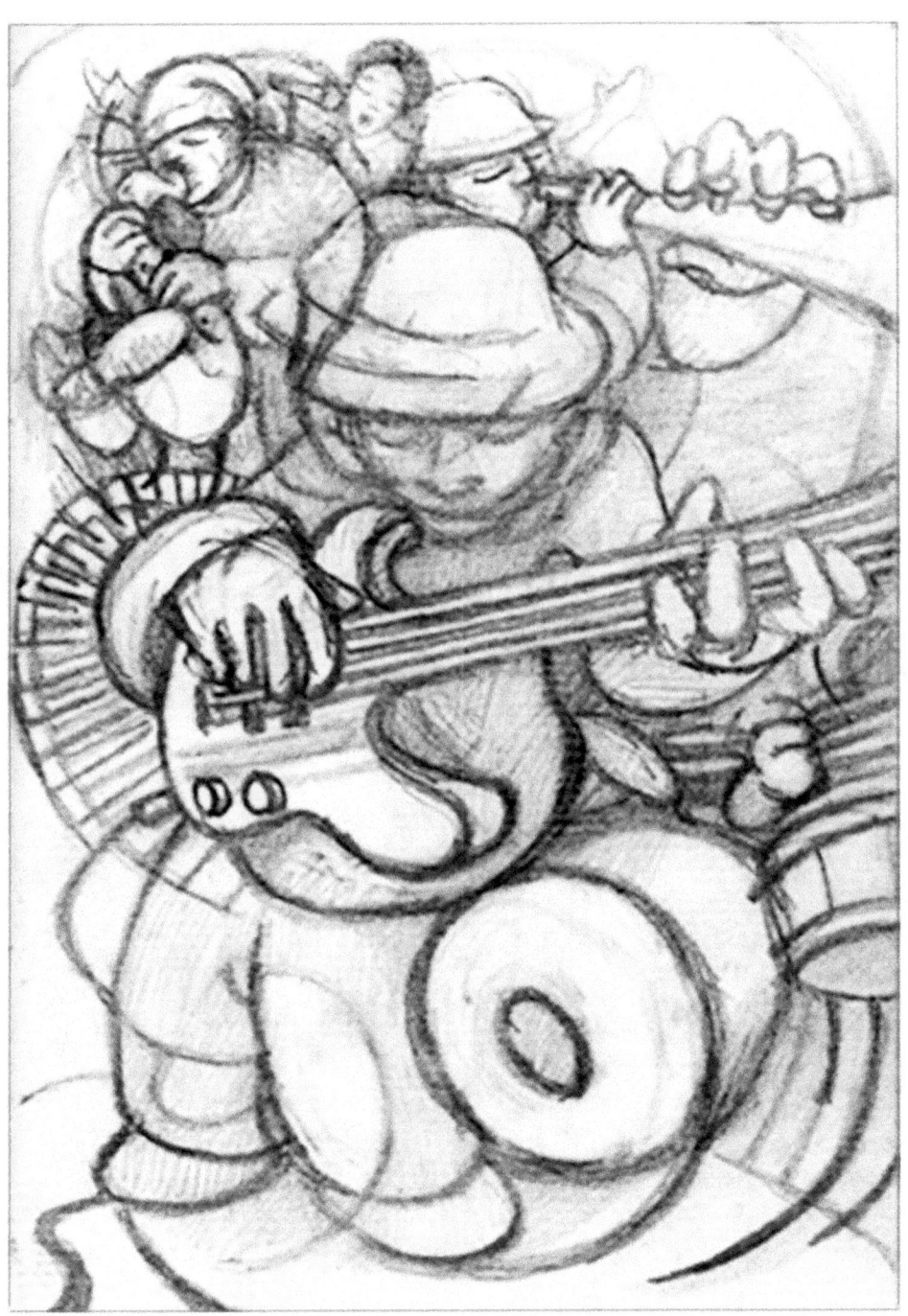

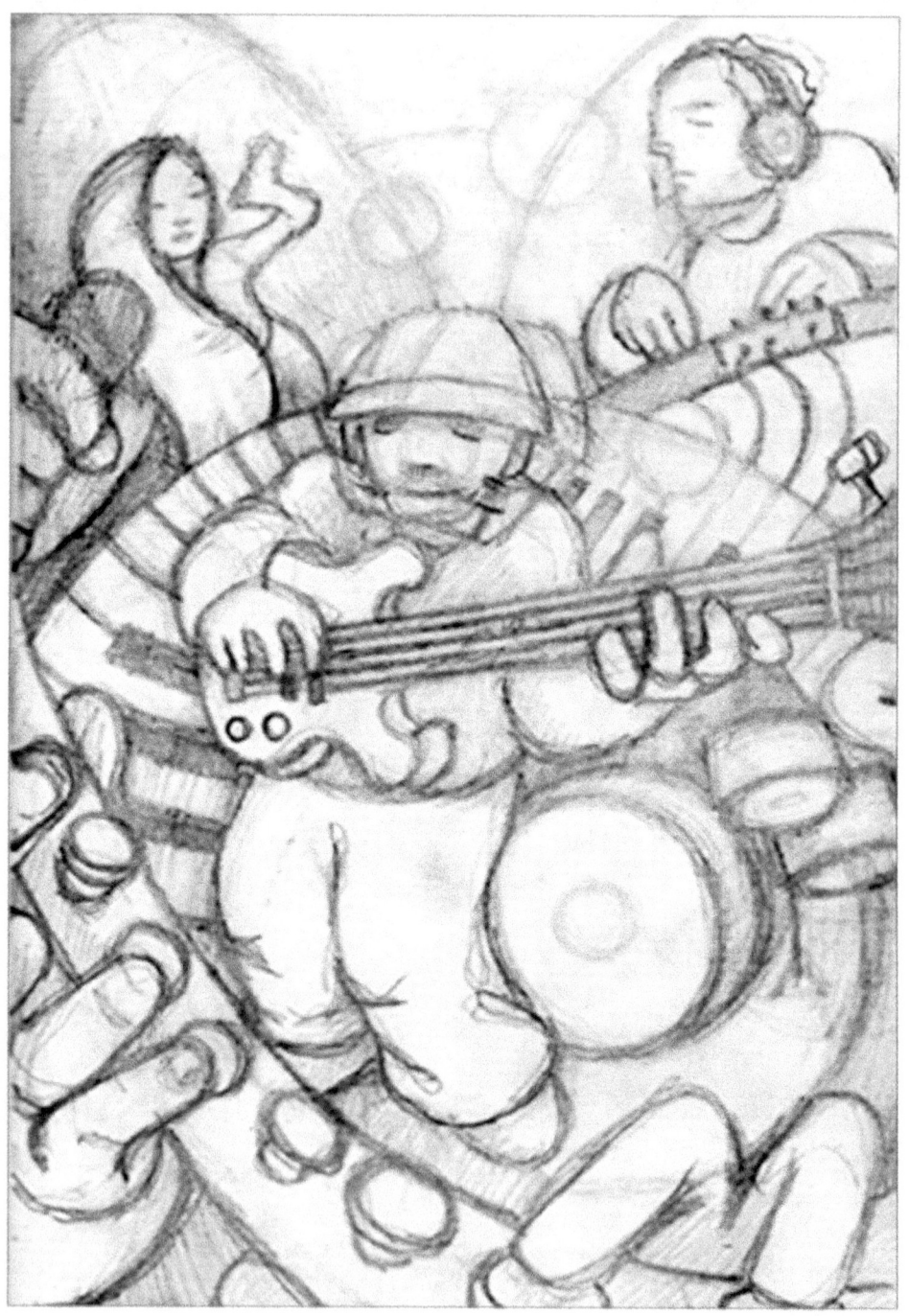

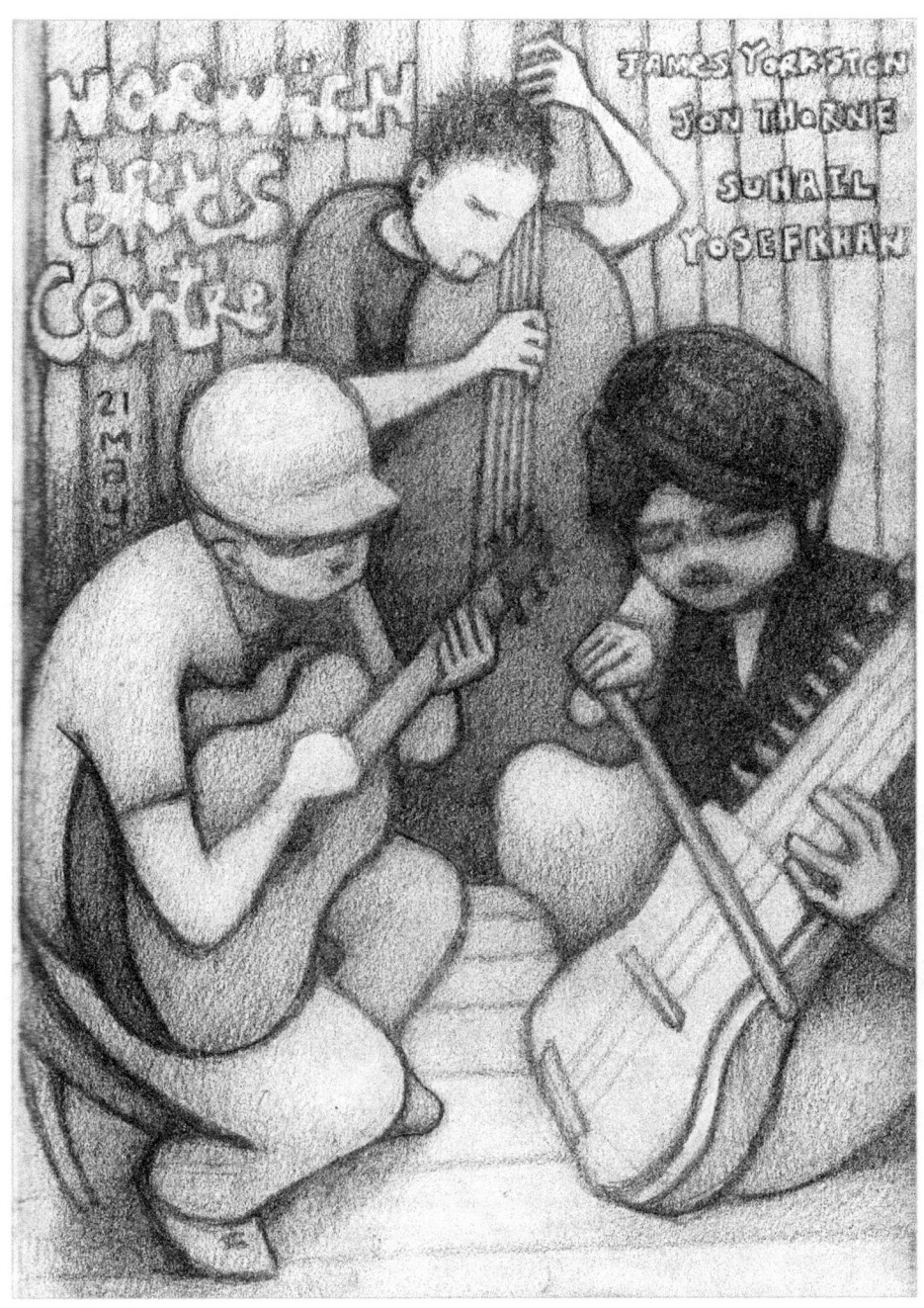

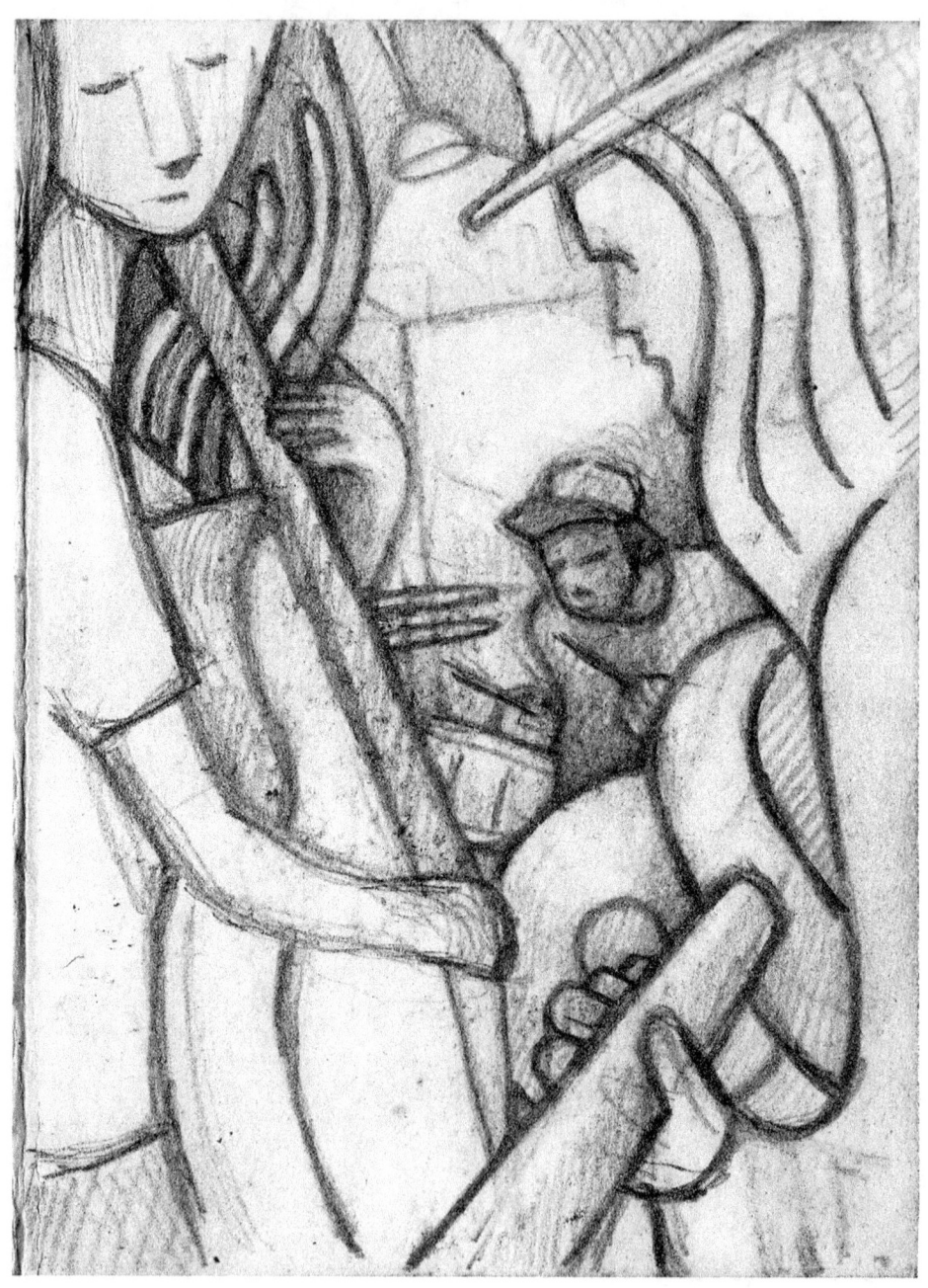

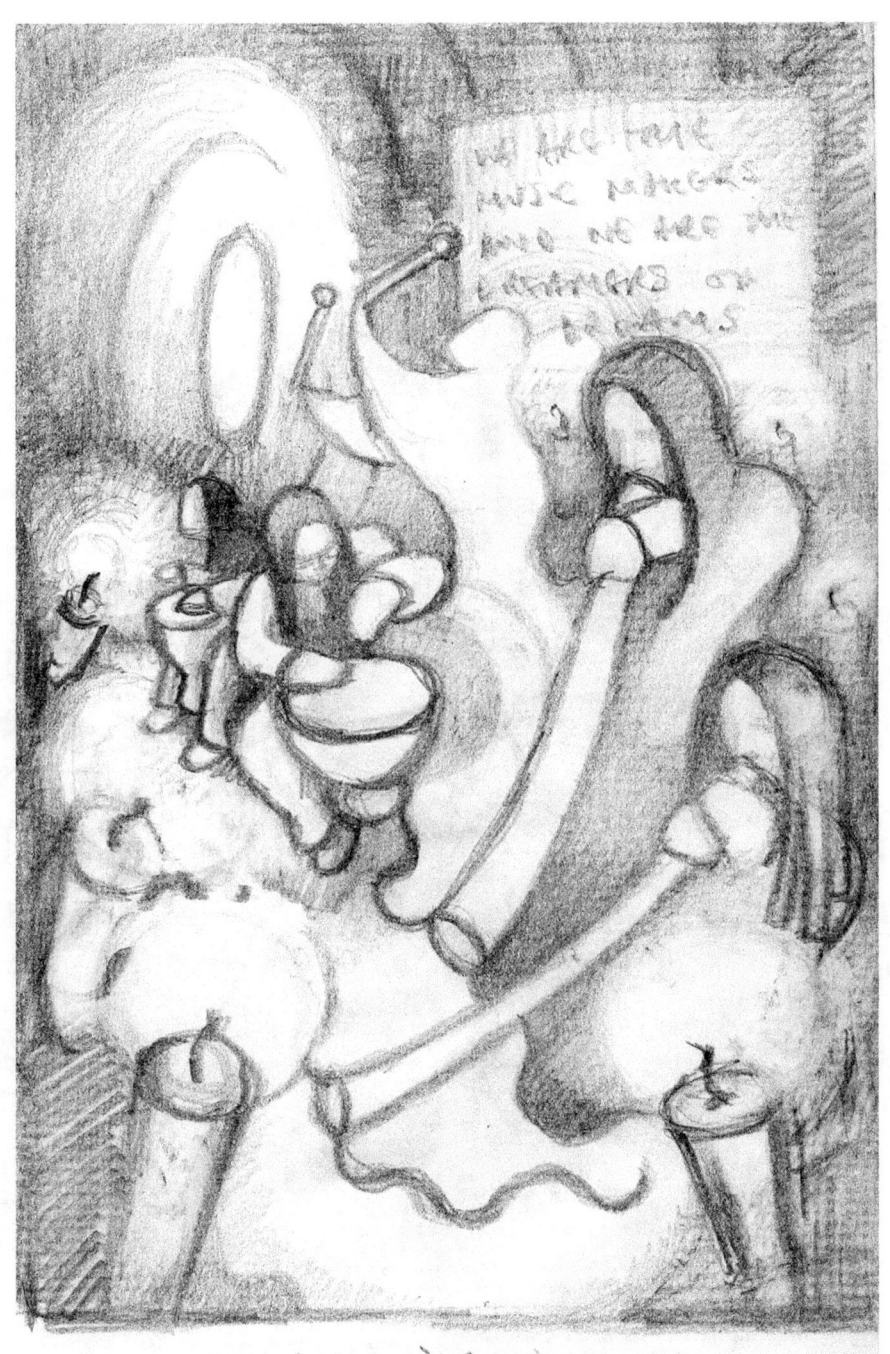

la tribù celice

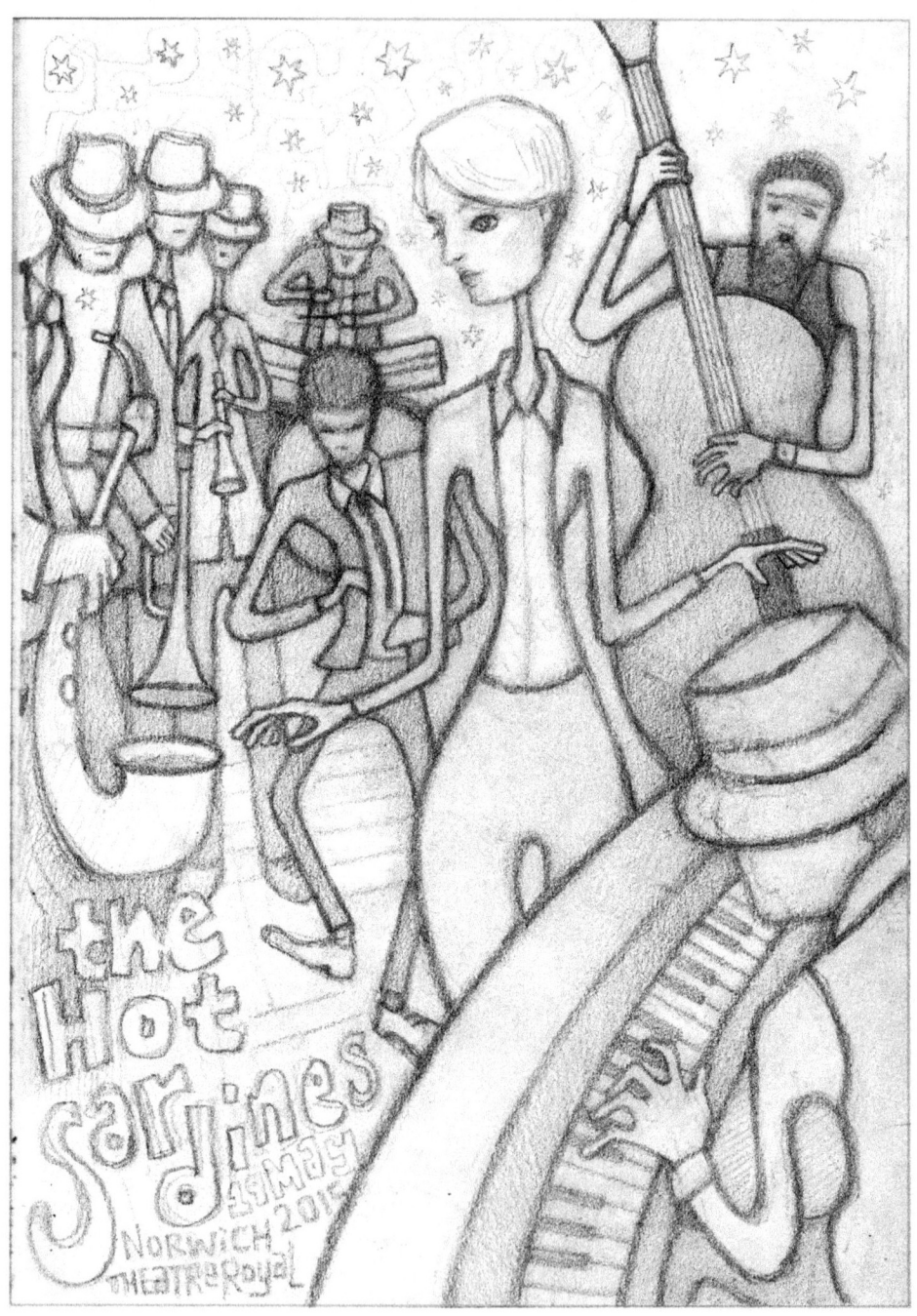

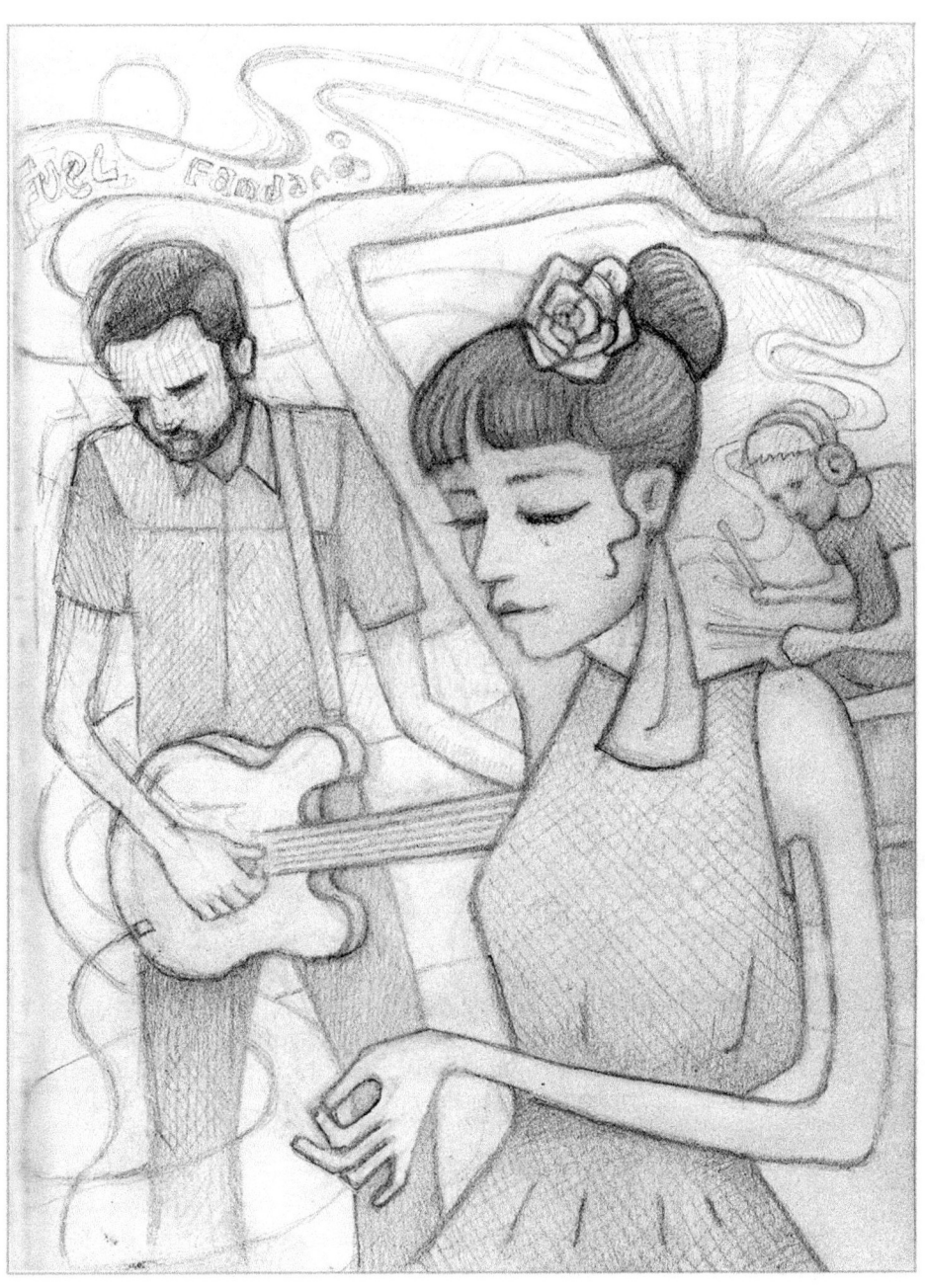

Things can get a little bit freaky sometimes and I am often accused of being disturbingly dark.

Drawing is my therapy; it is essential for my peace of mind and well being. I try to find a moment to sit down and draw everyday, otherwise I feel like I might go a bit crazy! I find it is the best way for me to release and sometimes also to understand any latent or subconscious anxieties.

In these moments it is not necessary to have an idea, or to be inspired before I start to draw, I just put pen to paper and see what happens, and am usually left bewildered. There are times when I can make connections between the images and current events in my life, and there are times when I have no idea at the moment of creation, but look back at a later date and can relate the image to how I was feeling during that period.

The text in these drawings is usually a stream of thought, possibly everything I want to say in life but cannot or know not how. Again of course, this text is usually in code!

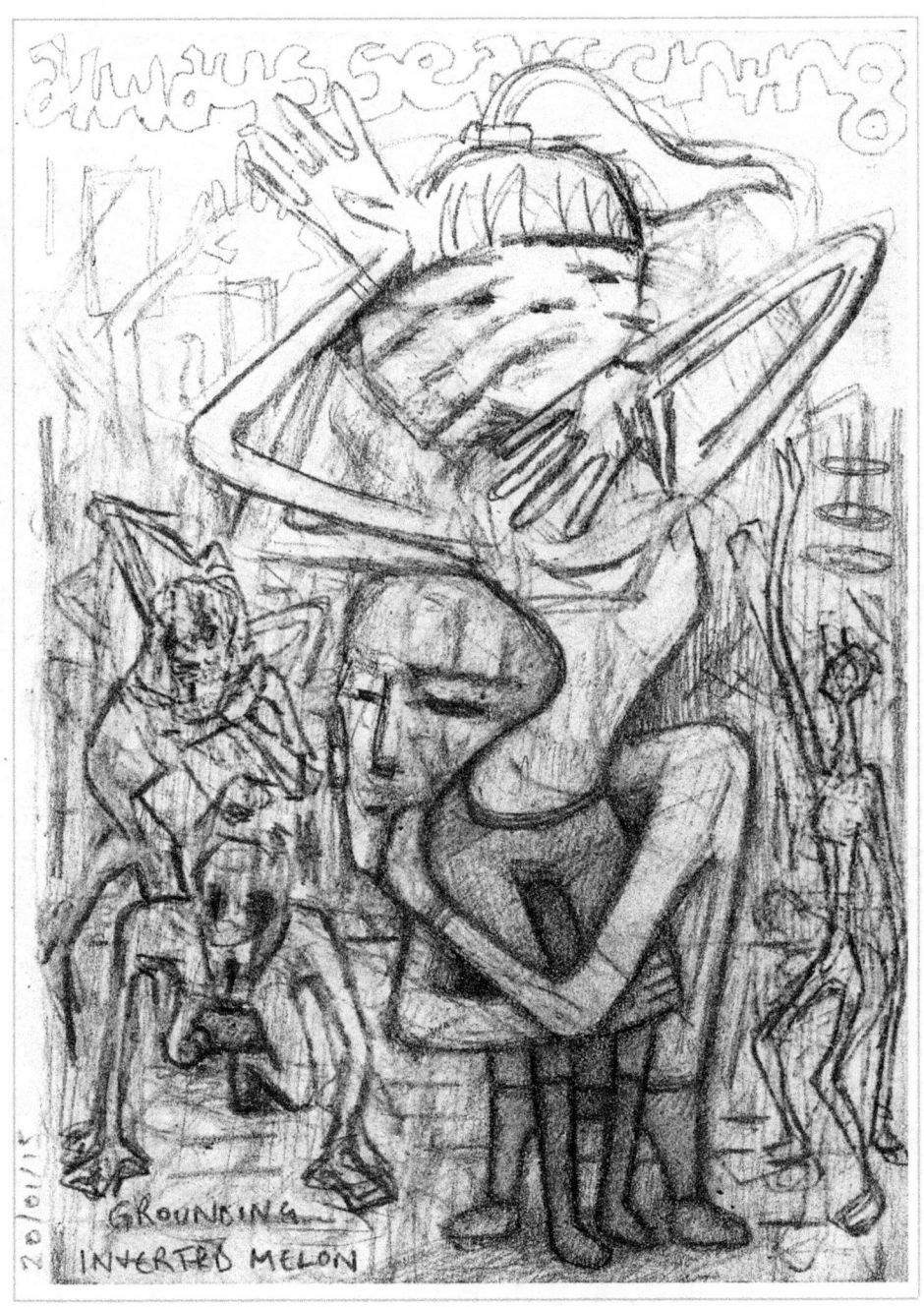

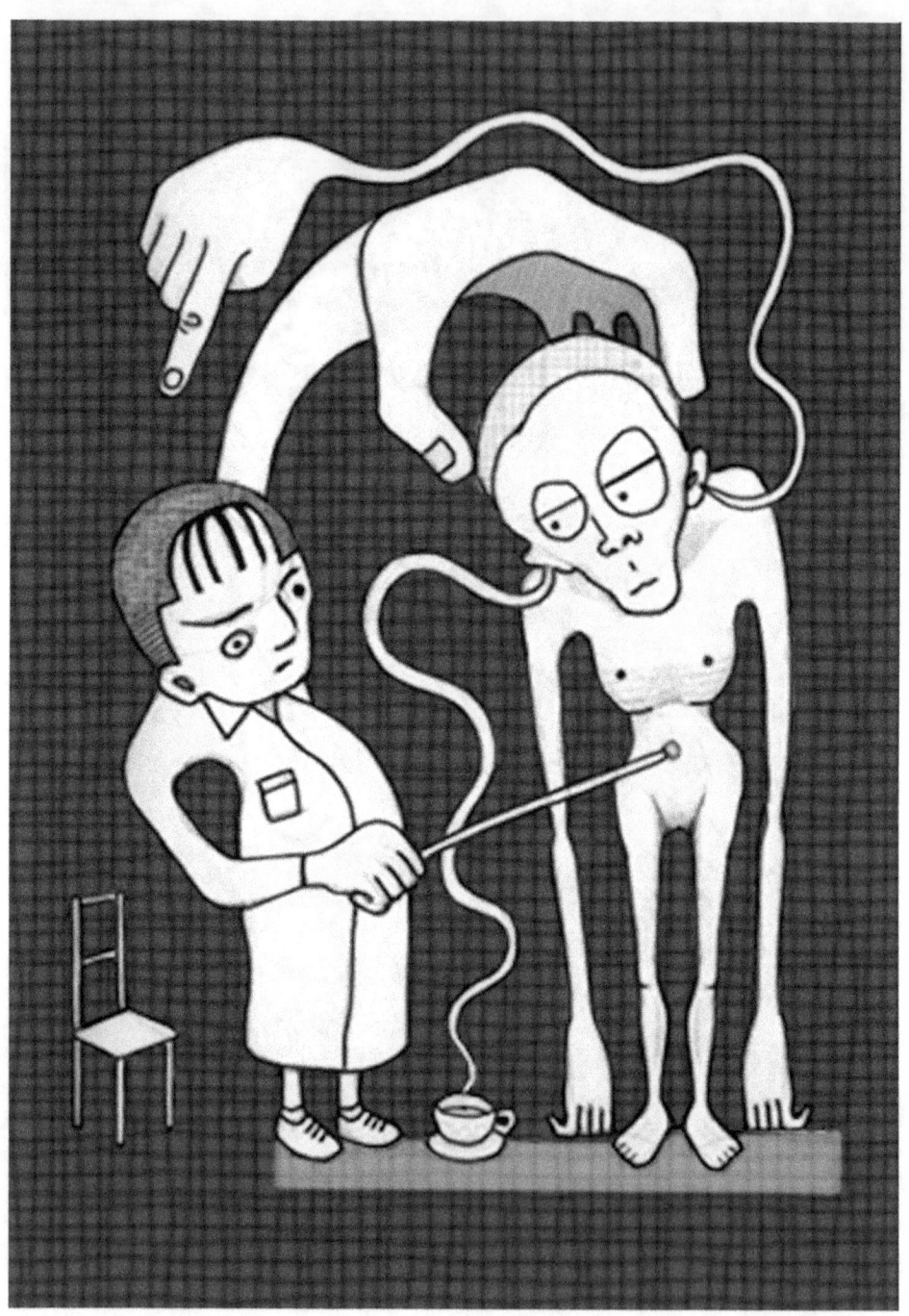

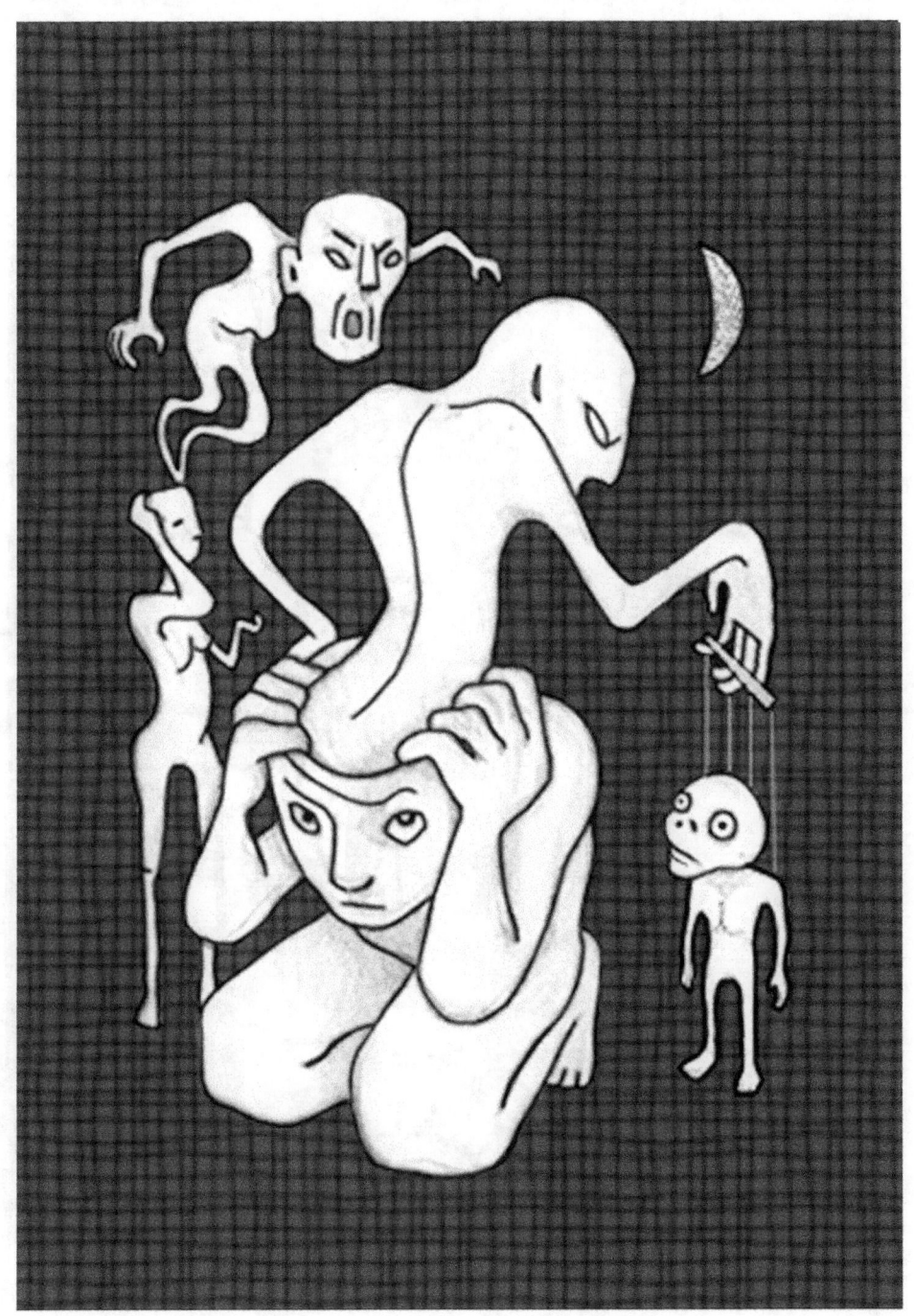

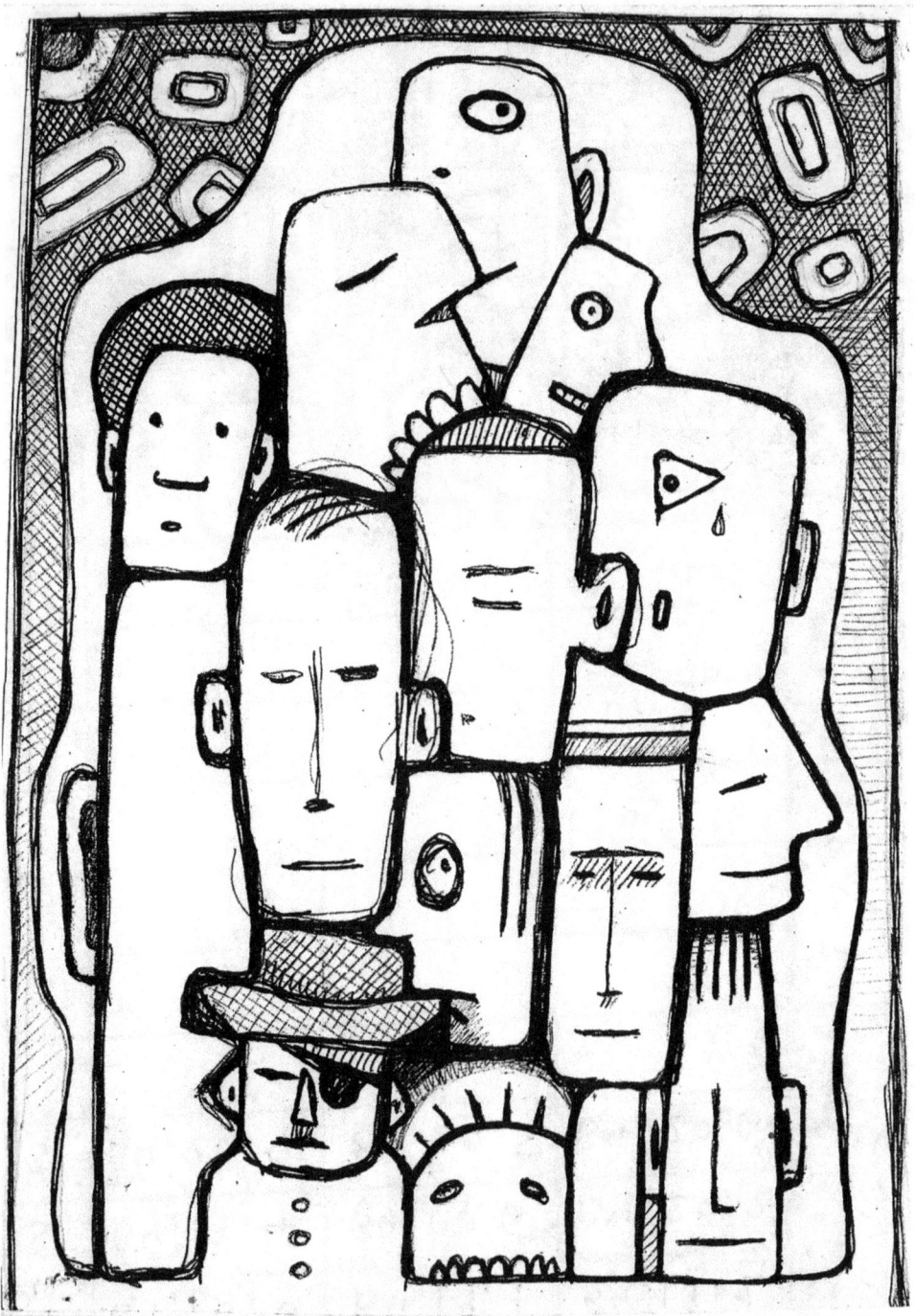

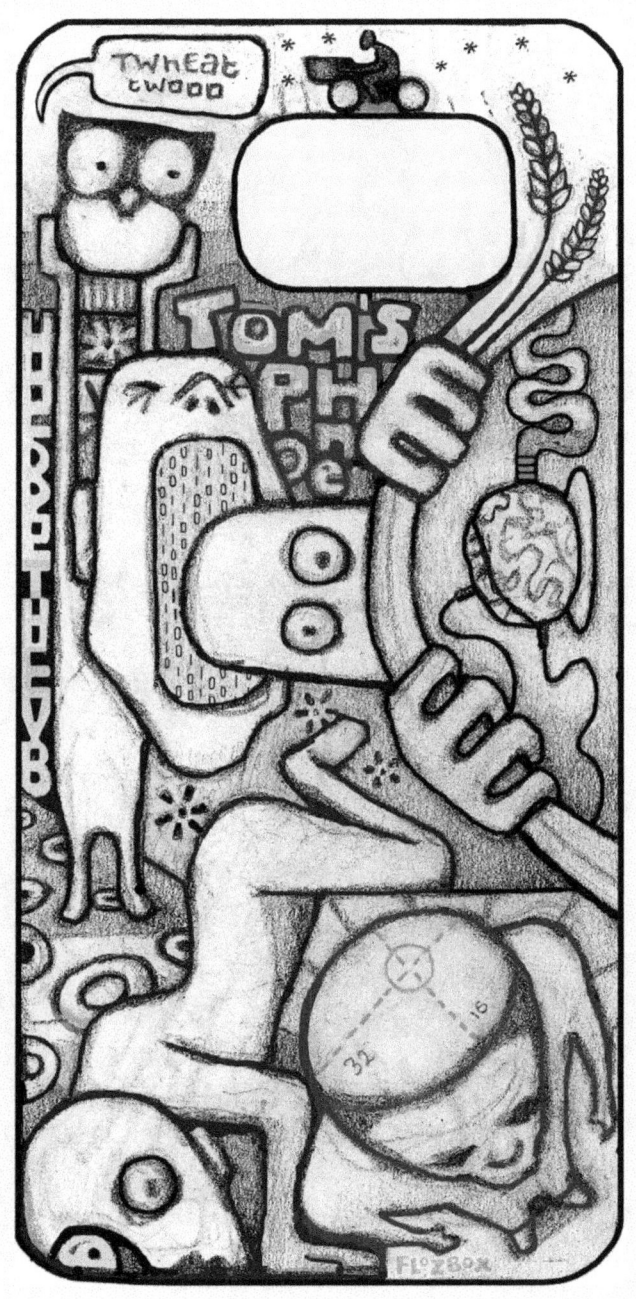

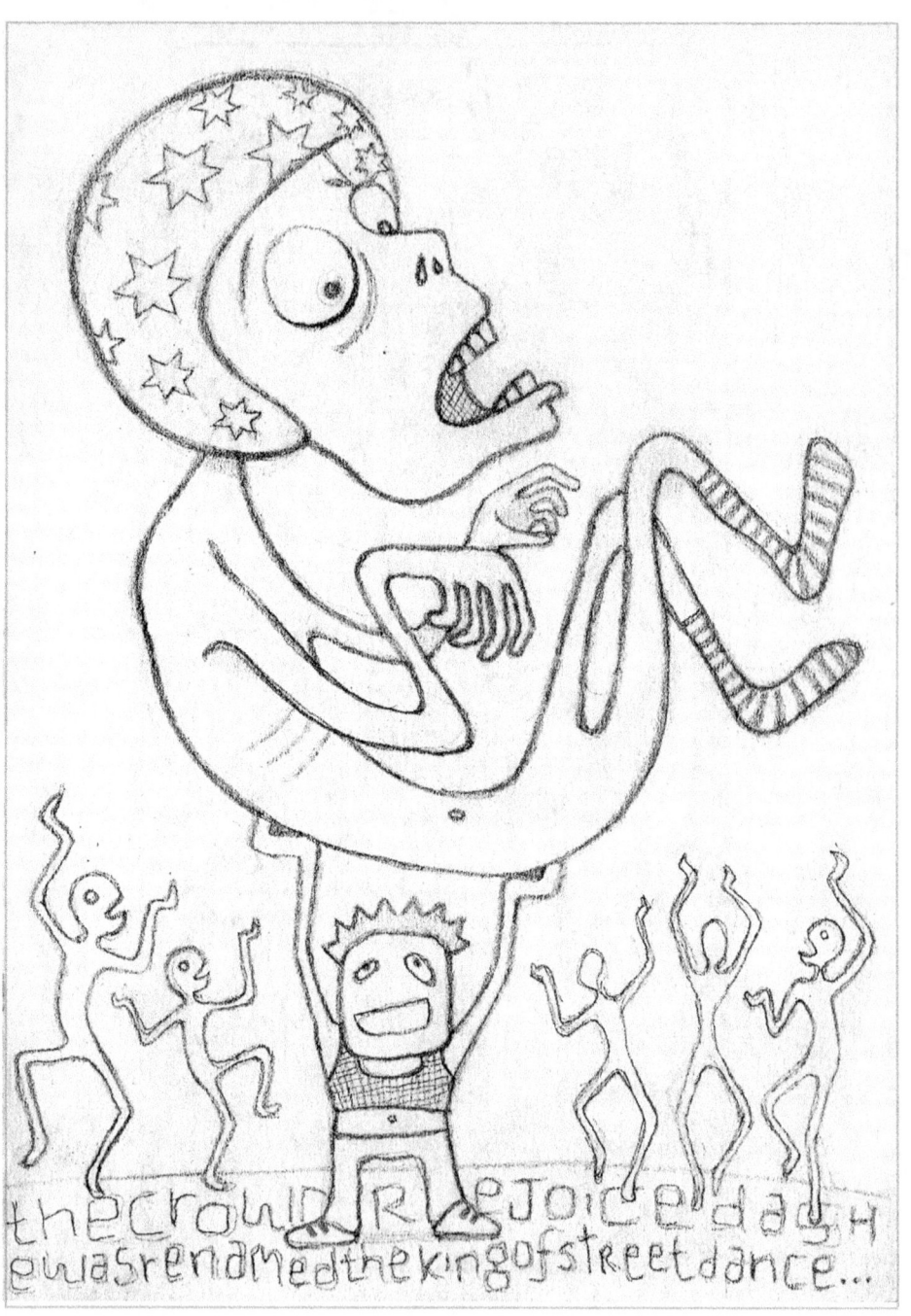

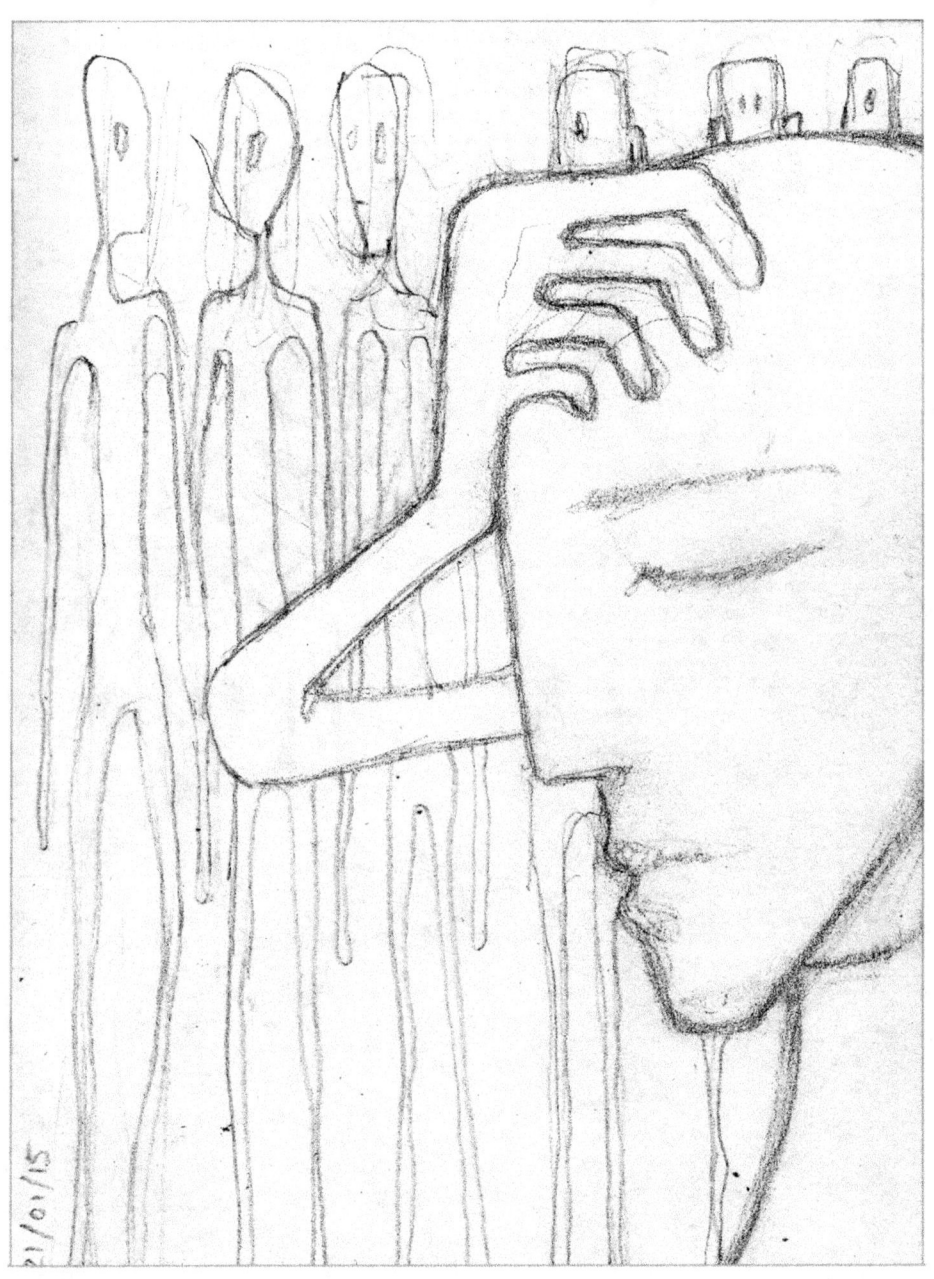

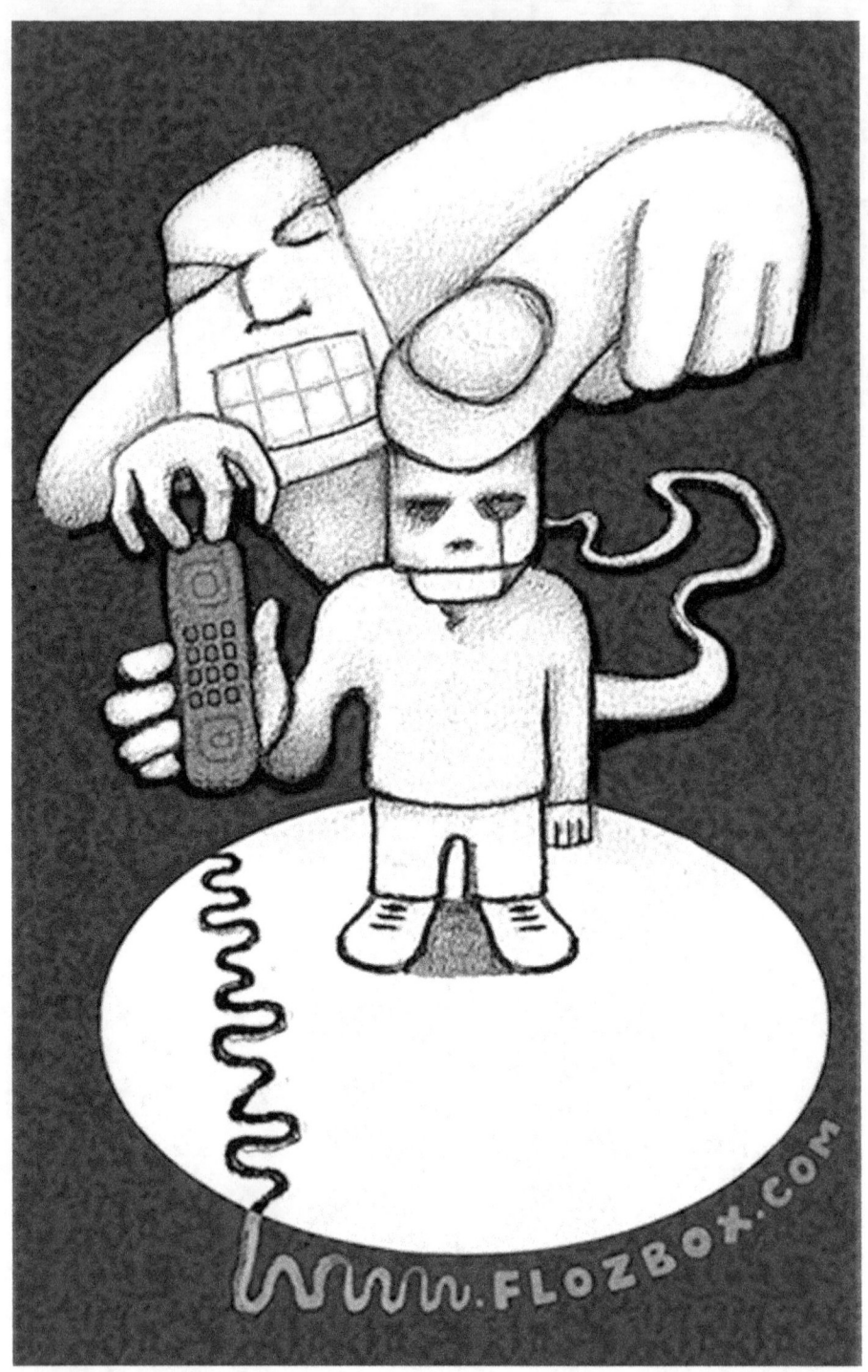

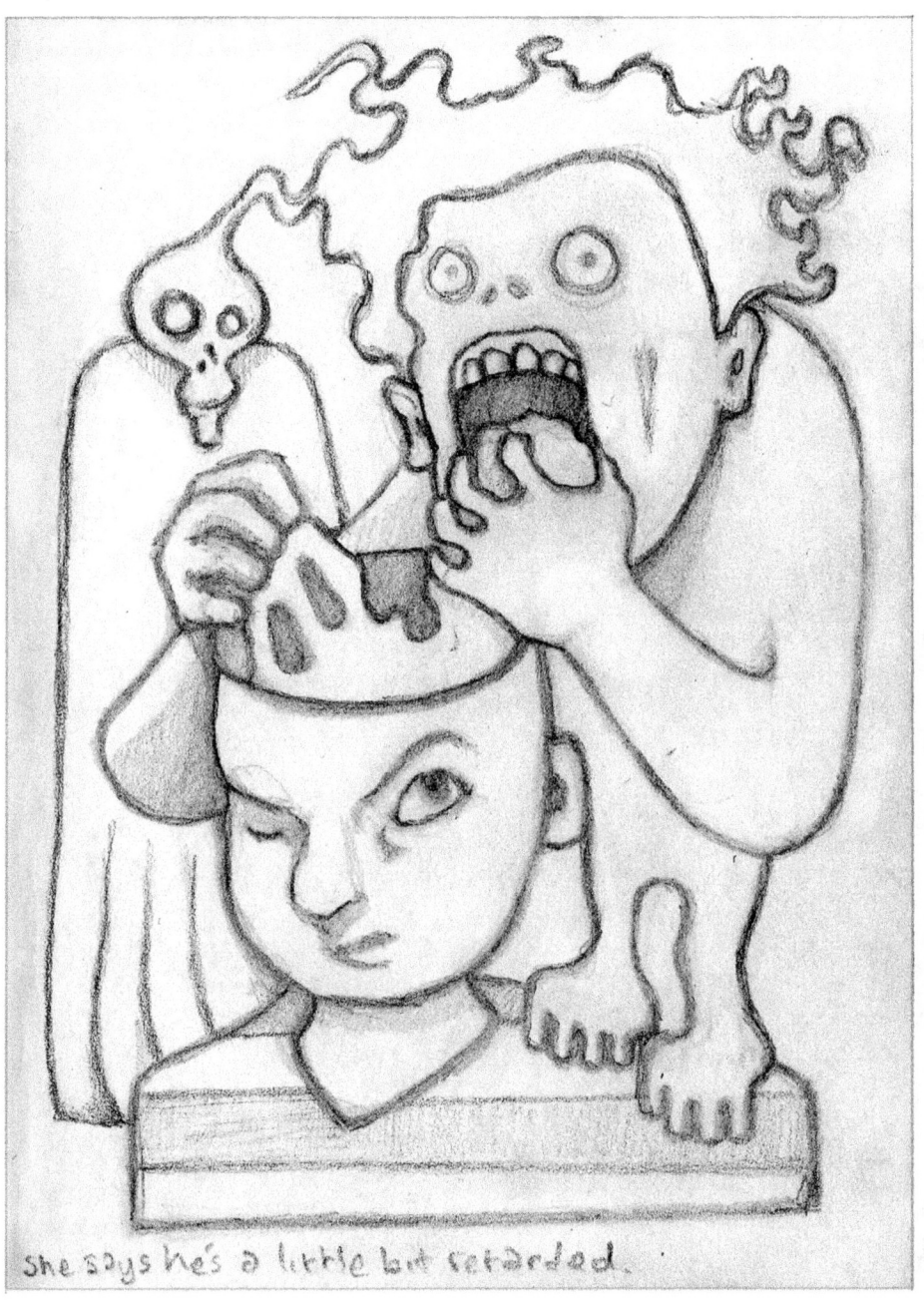
She says he's a little bit retarded.

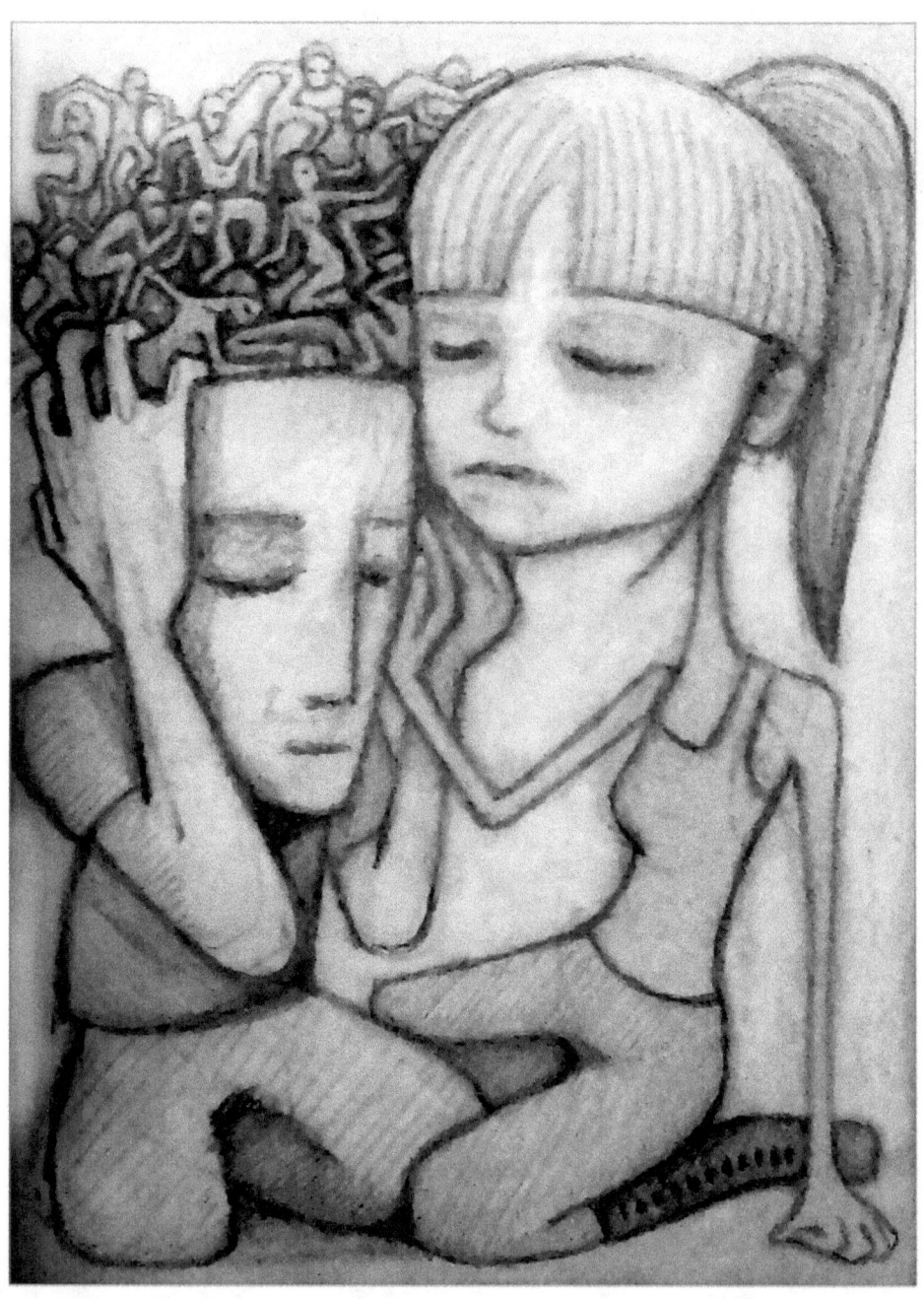

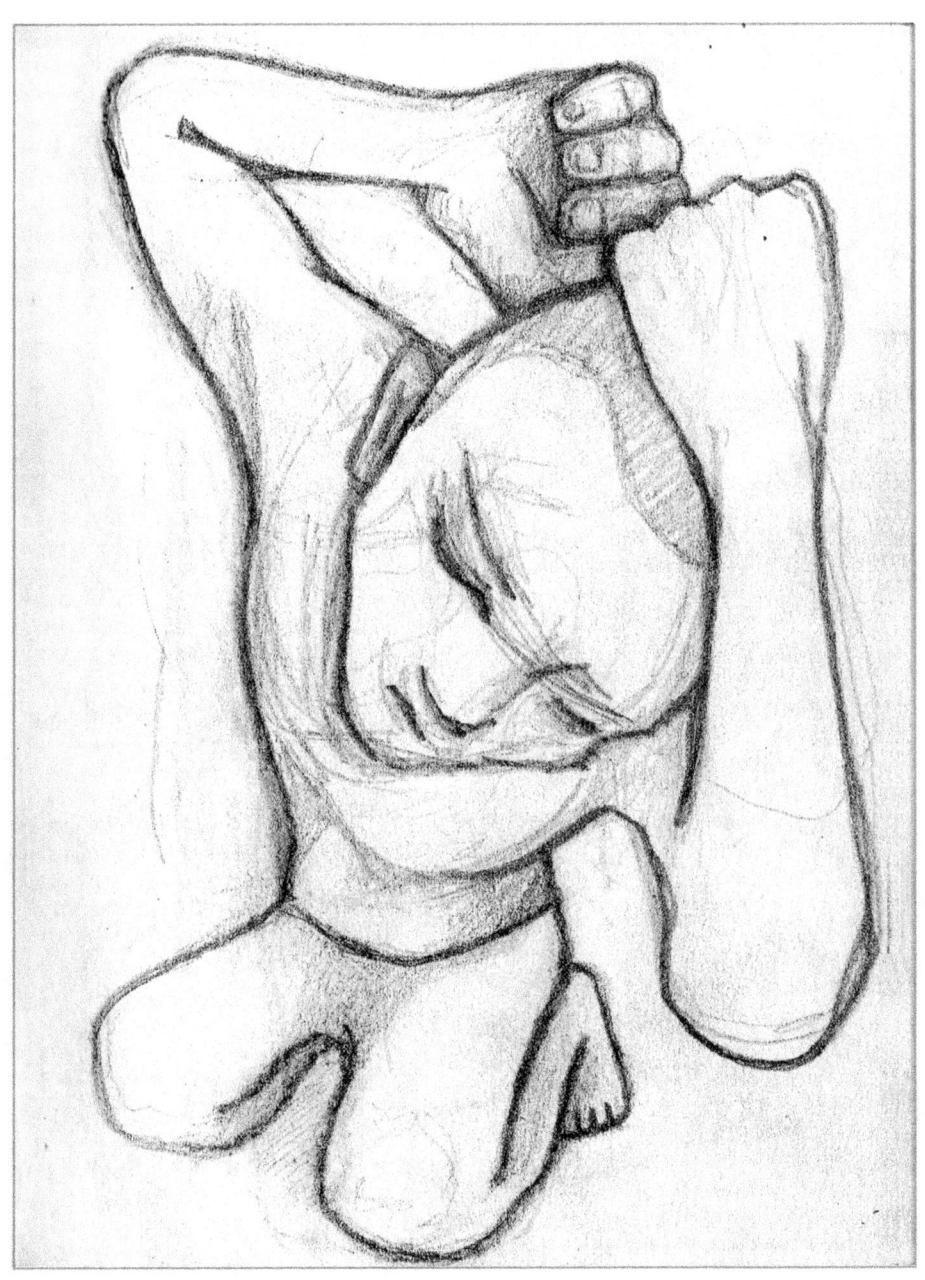

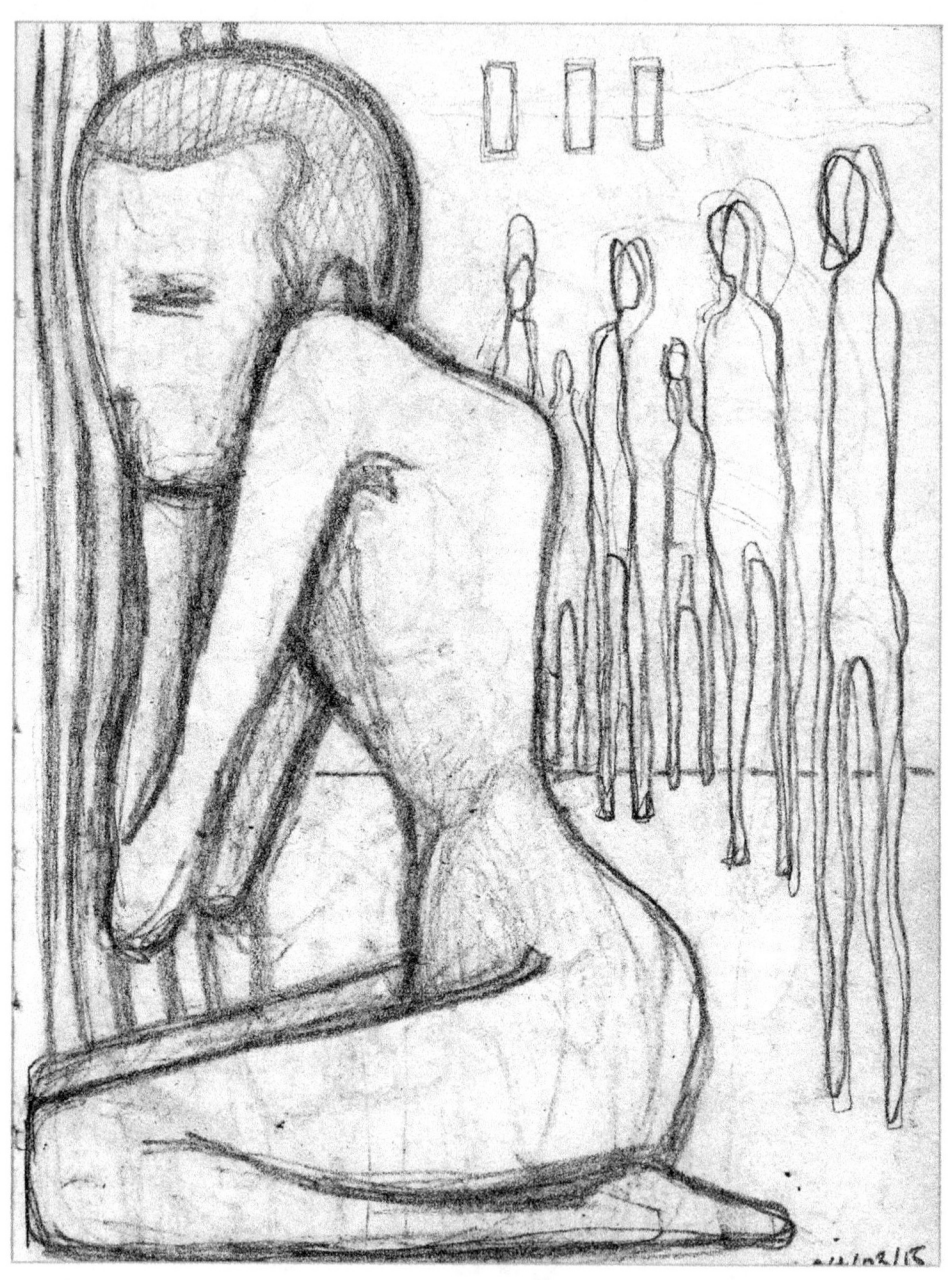

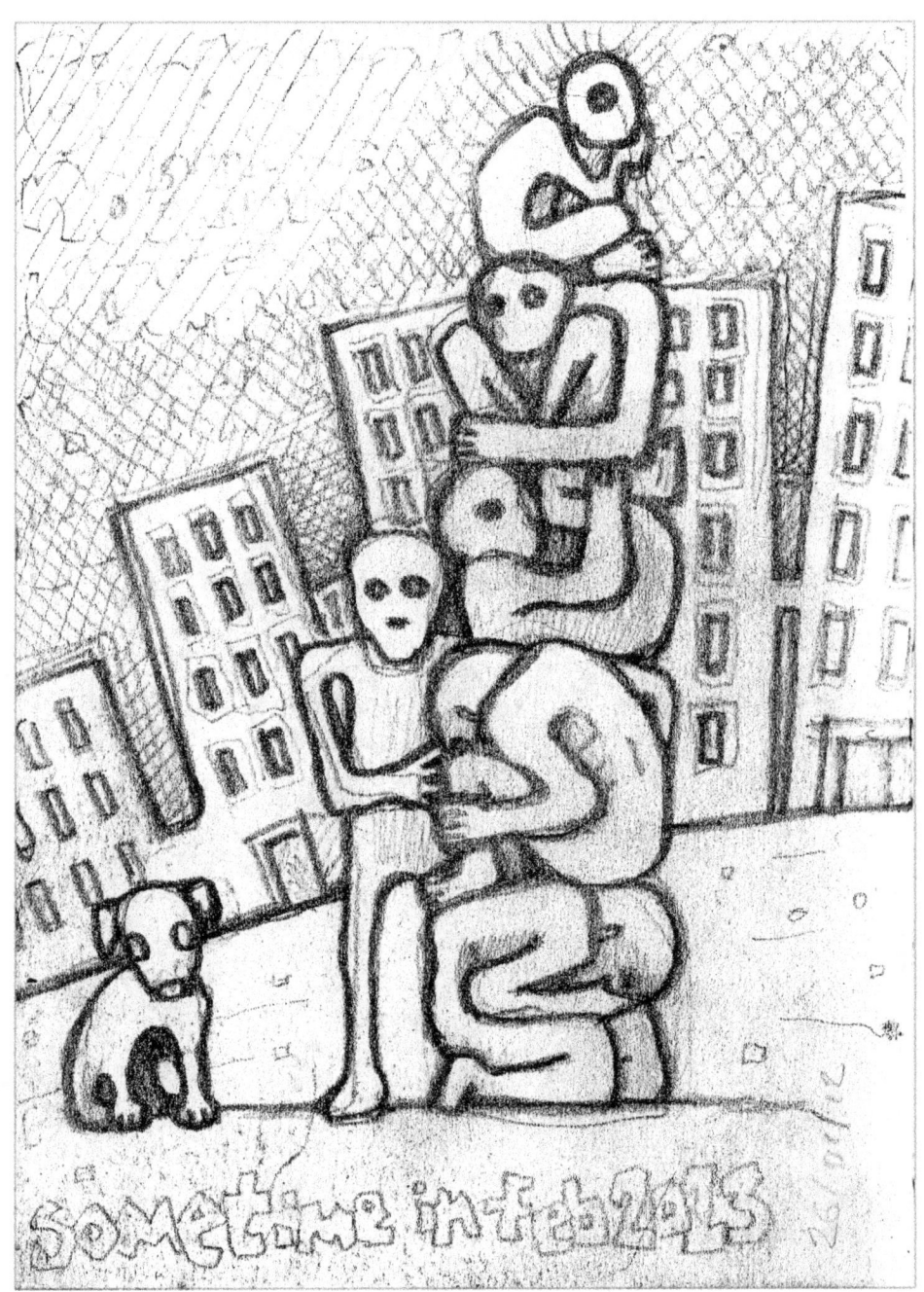

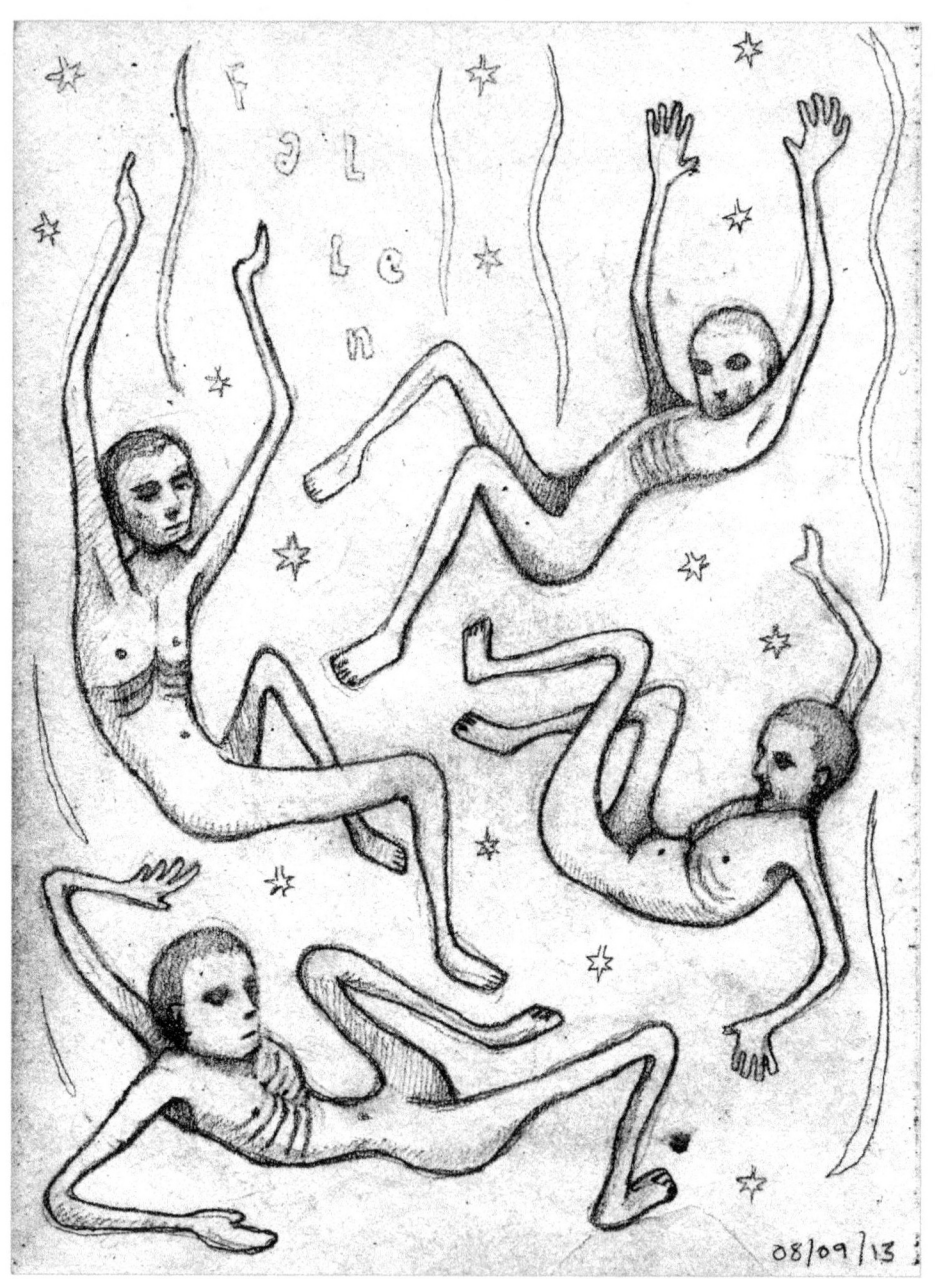

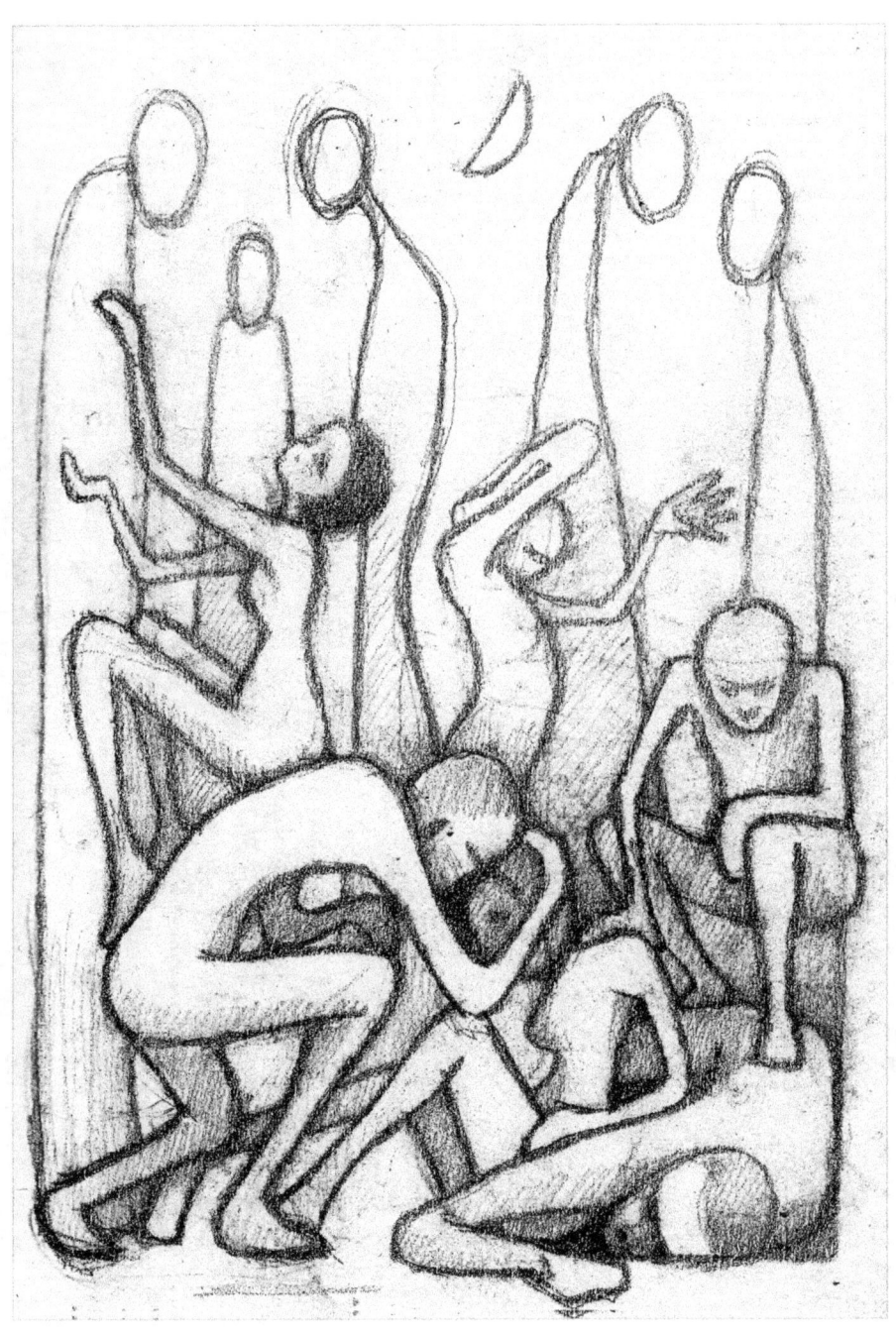

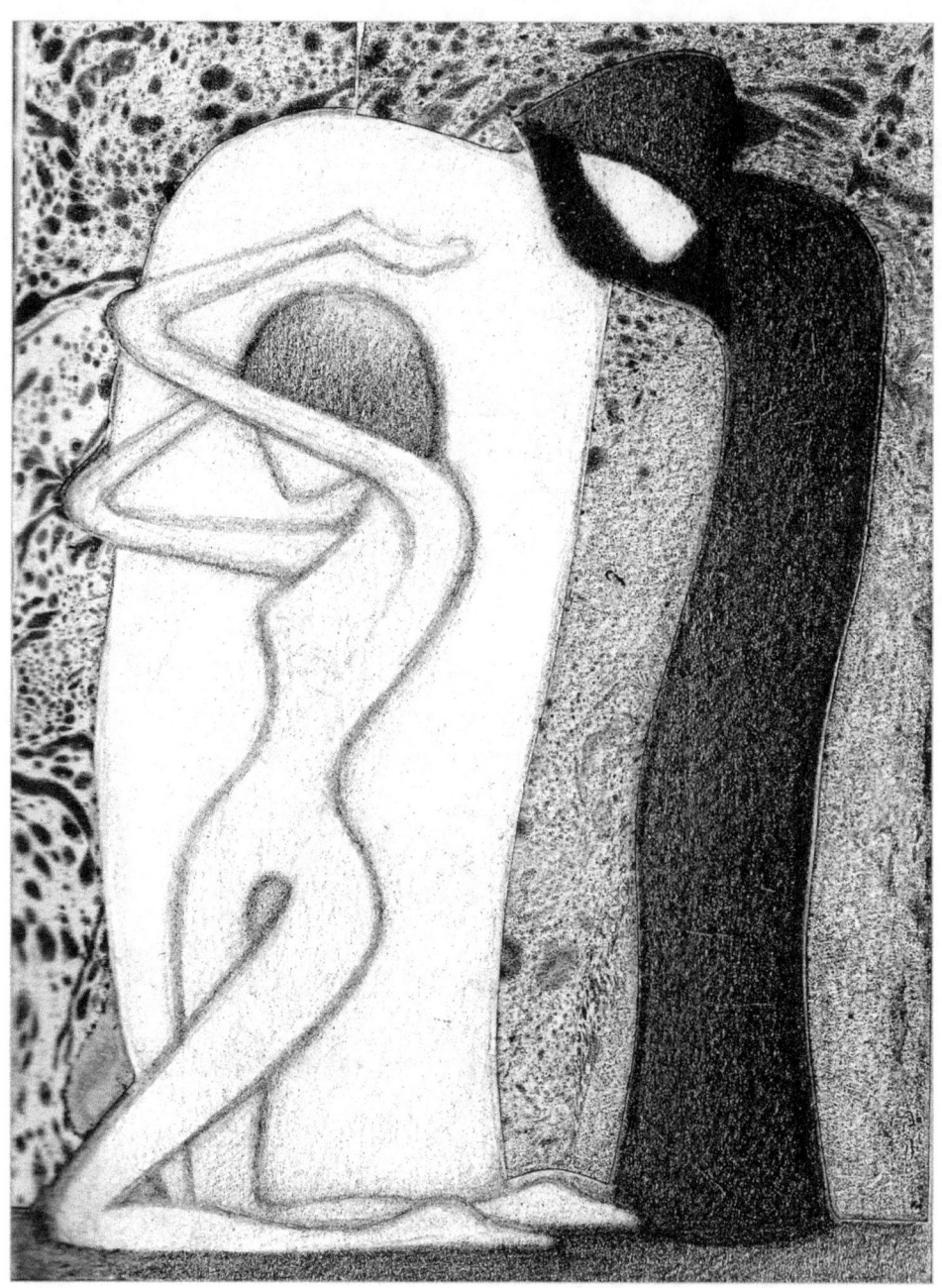

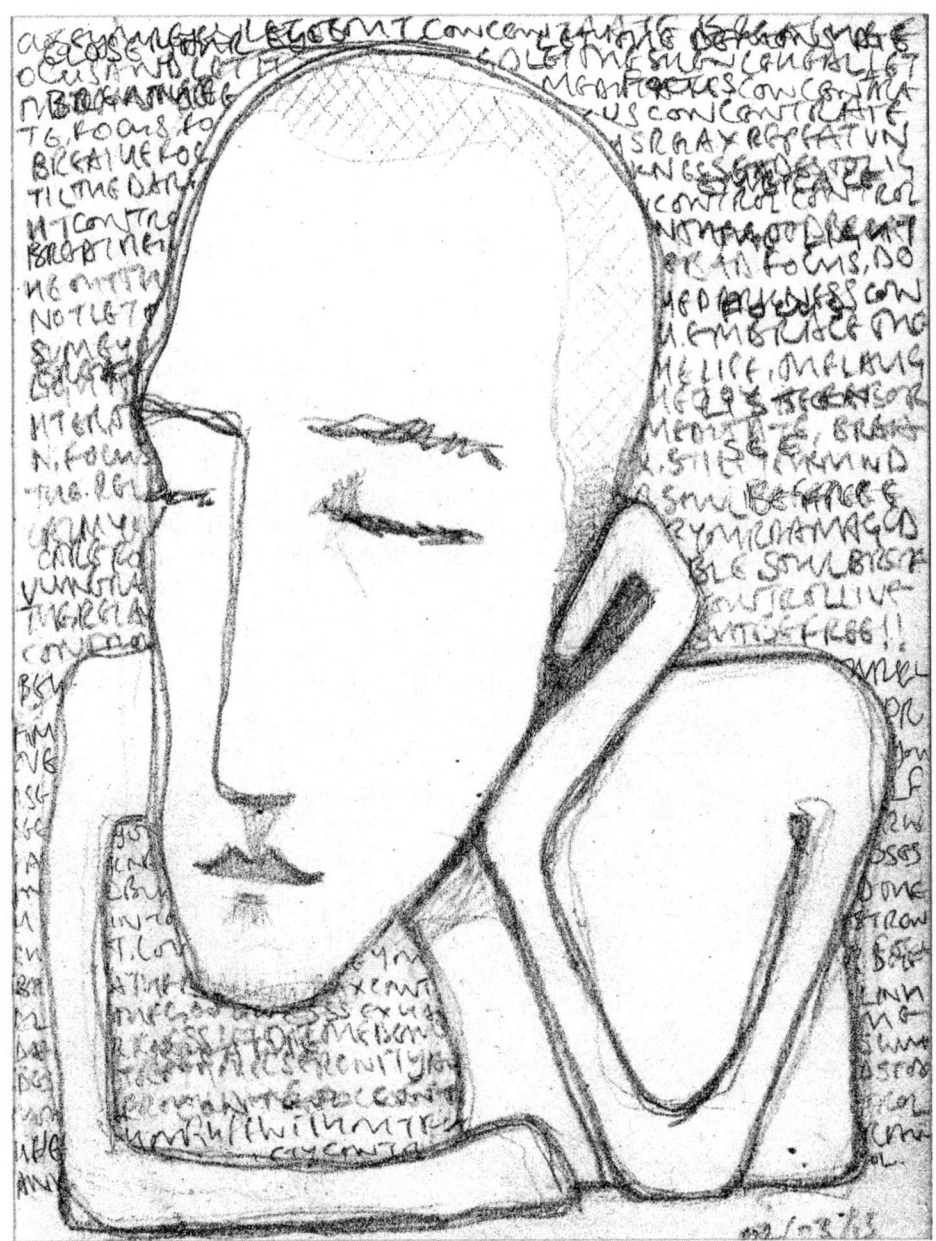

I am lucky to know love, to feel it's warm embrace, the comfort and security it can bring. These are the sentiments that manifest themselves most prominently in the next selection of drawings.

The reason behind creating images of this nature is less clear to me, as I do not need an outlet to express these emotions in the same way as I need the outlet for my dark and freaky doodles. Yet there are times when I sit down to draw, I clear my mind and this is what comes.

I hope even though they are clearly very personal drawings, that the viewer can also enjoy a sense of love and tenderness.

My first venture and growing interest in cubism came from a moment in which I ran the risk of making one of these drawings too explicit. So I cut the piece up and put it back together out of order and it looked wicked!

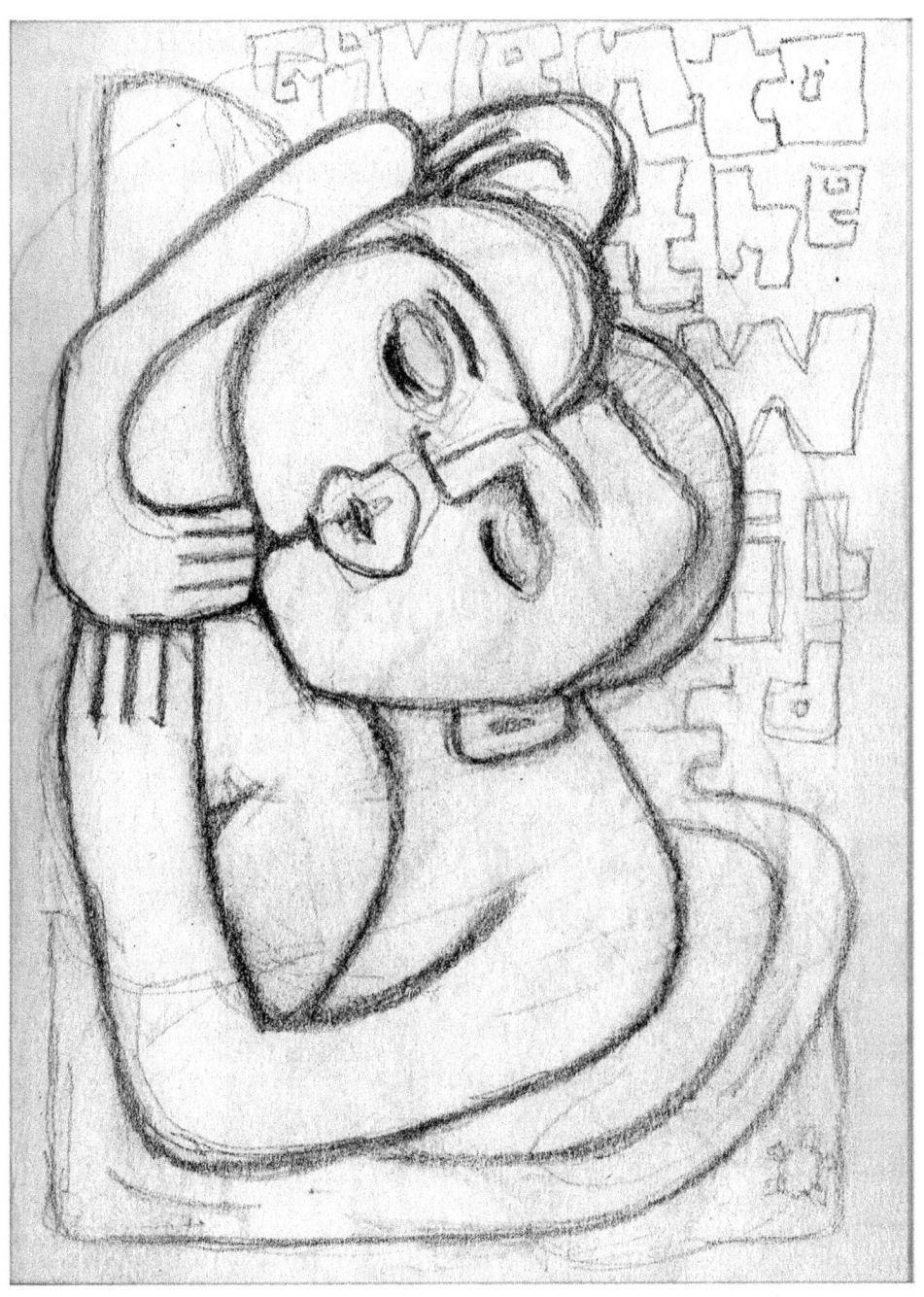

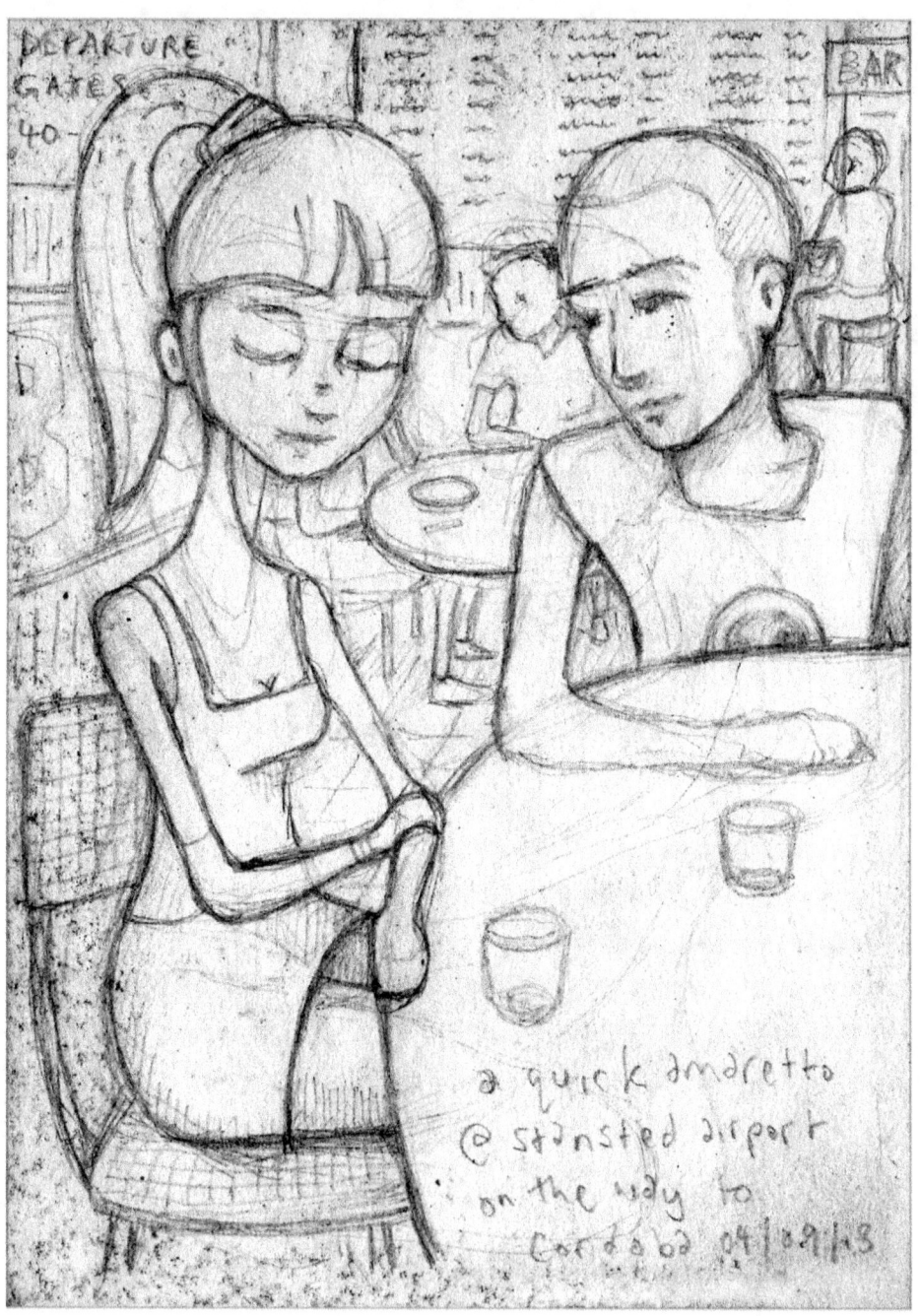

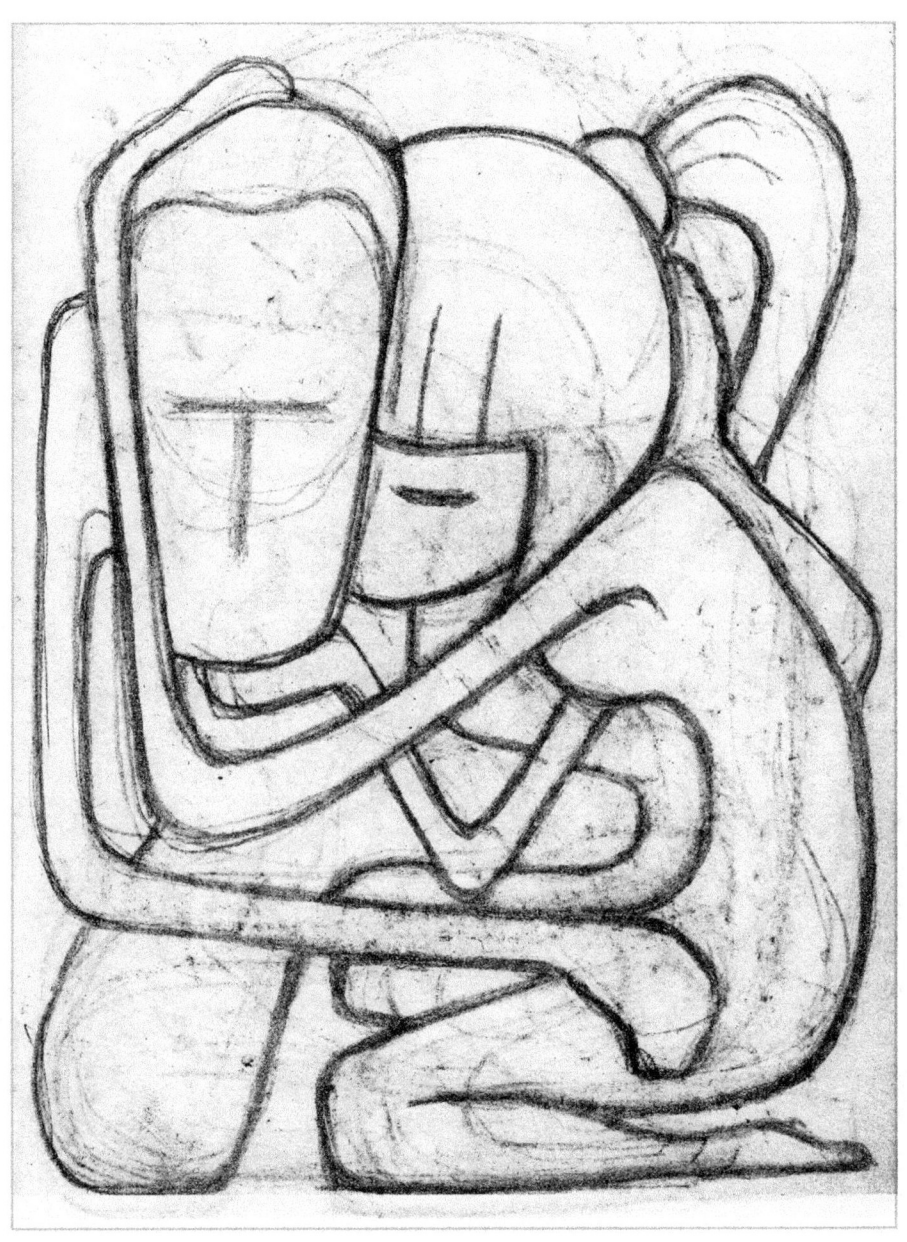

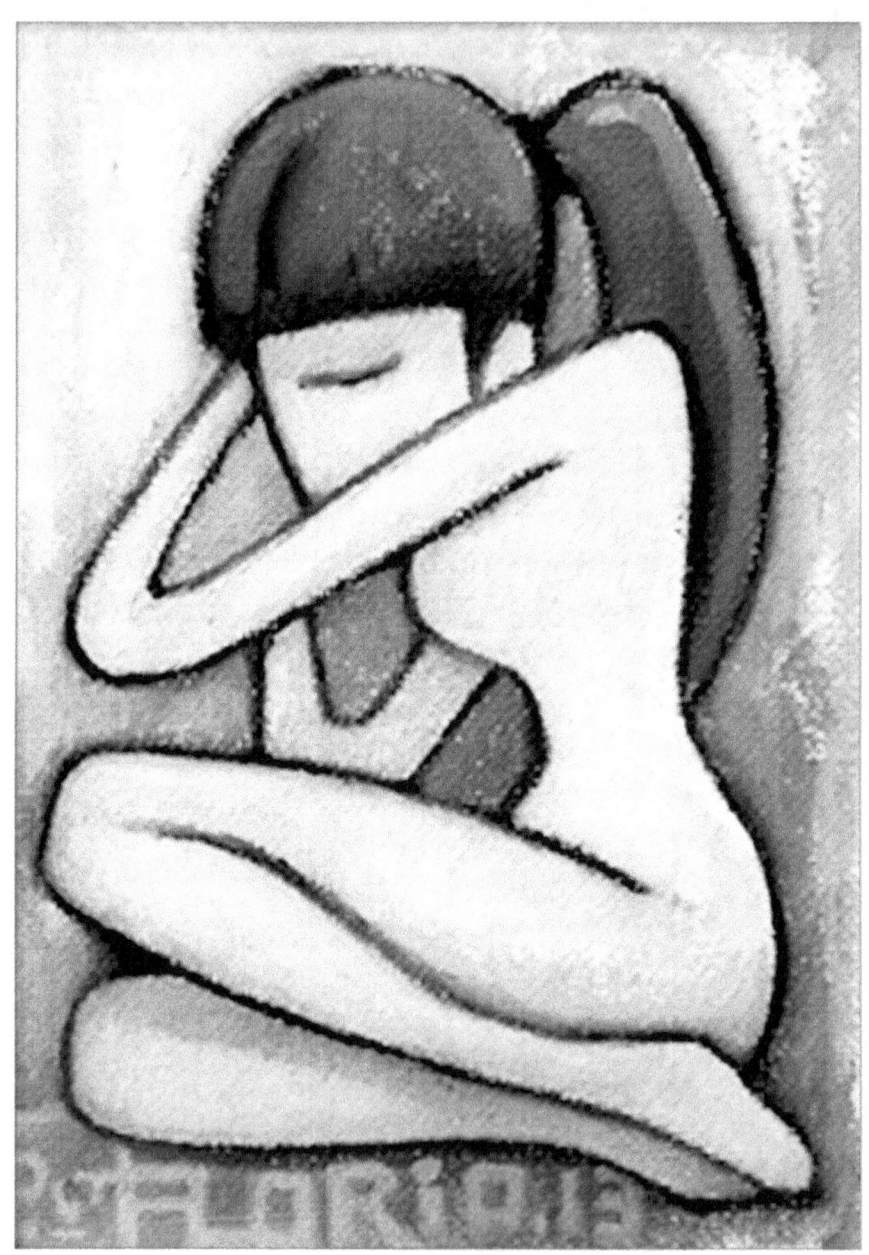

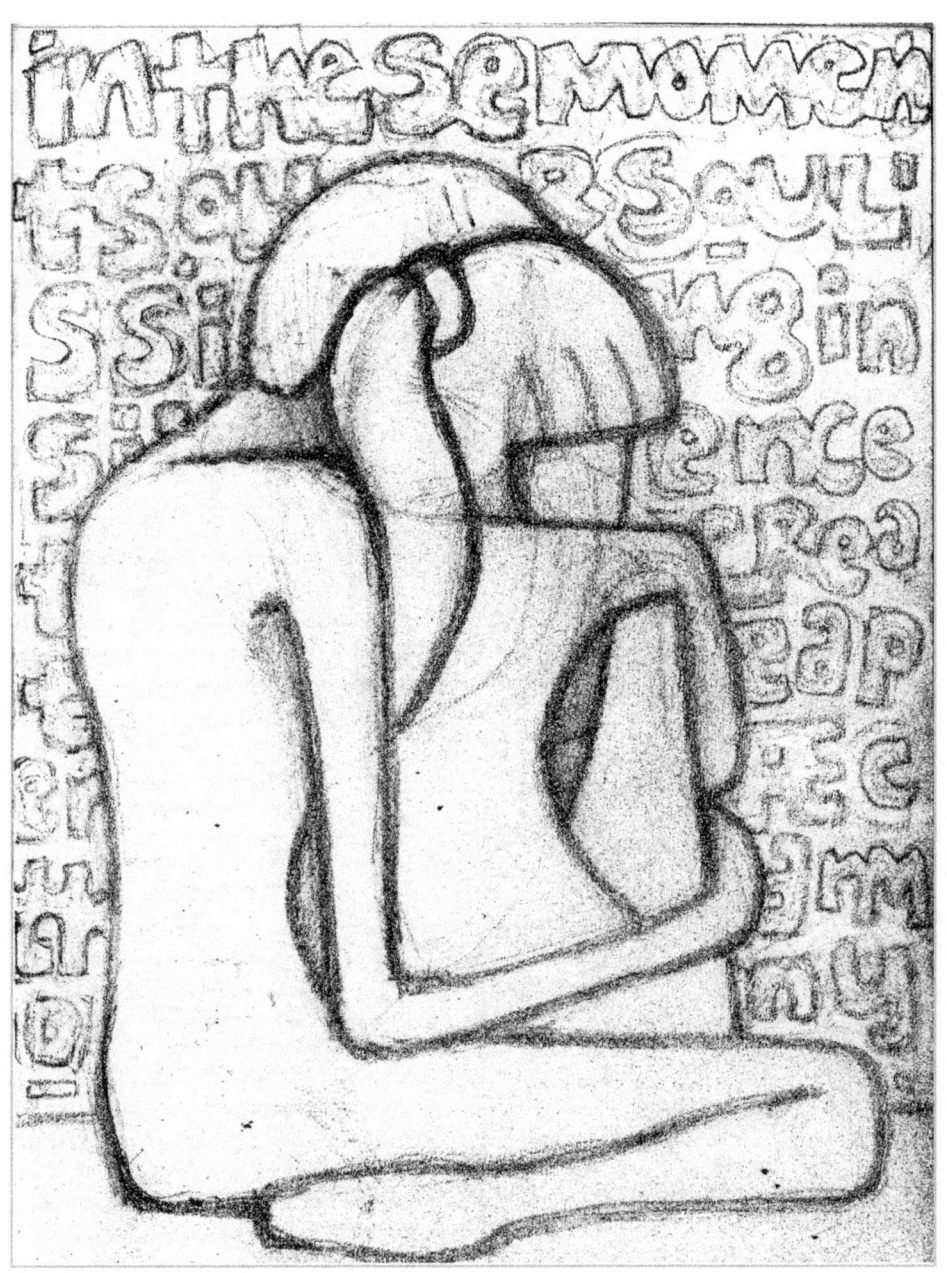

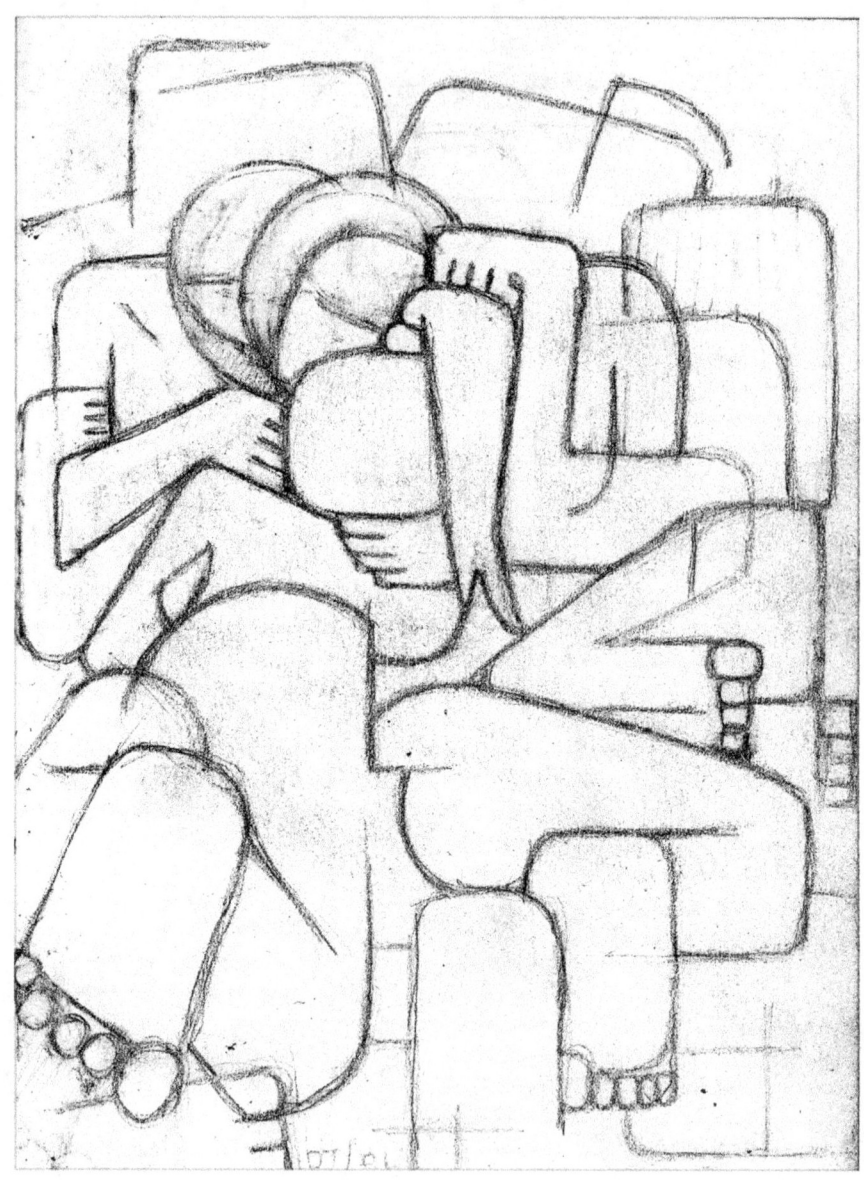

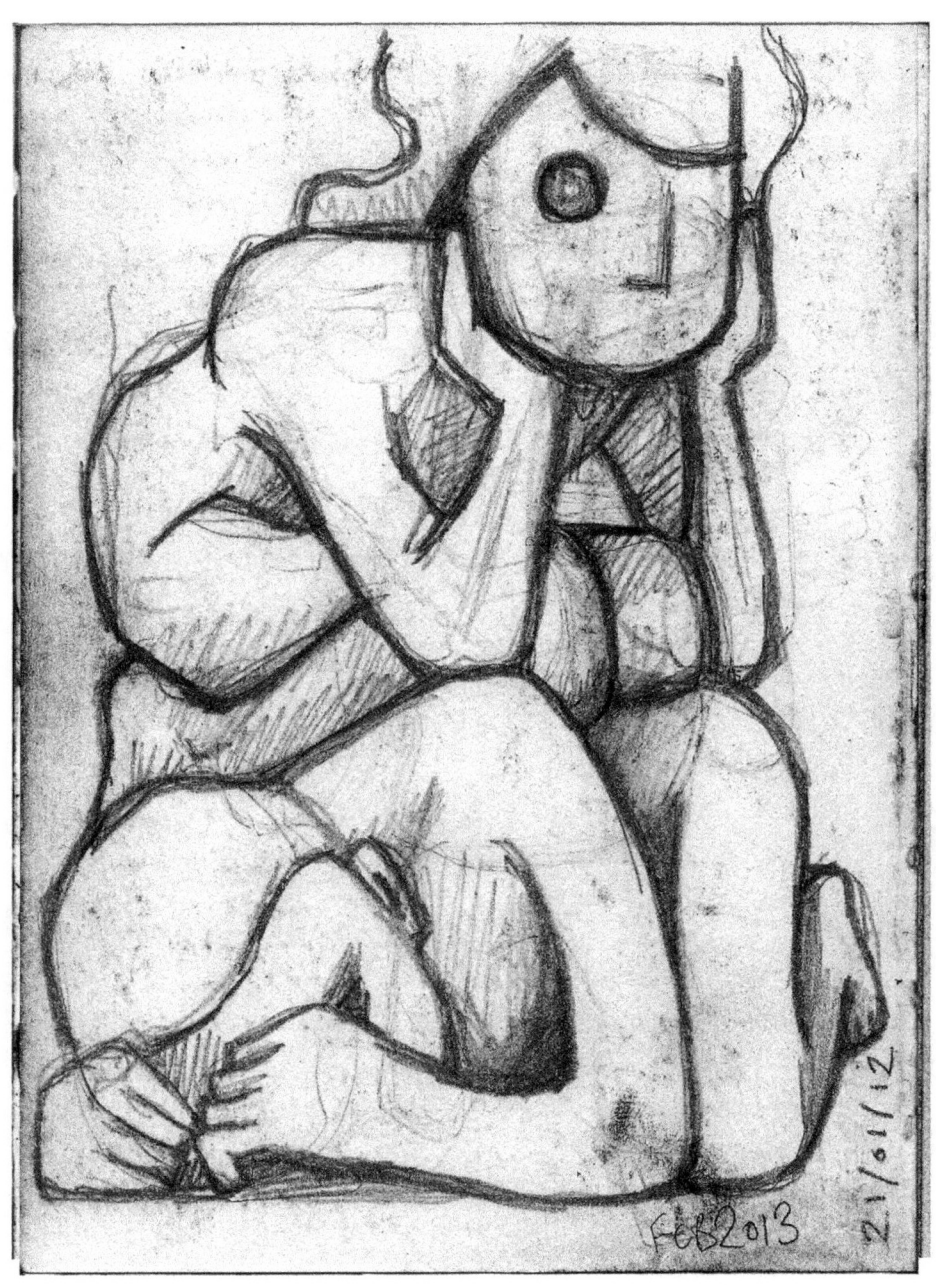

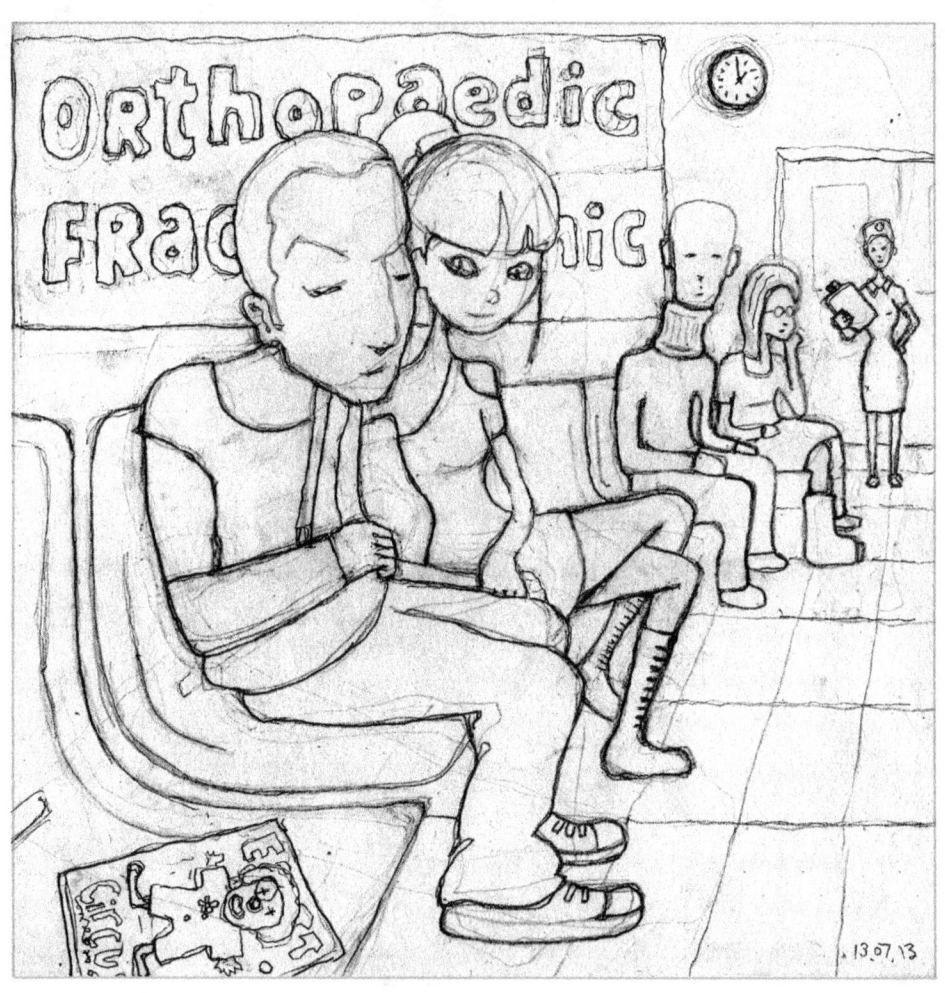

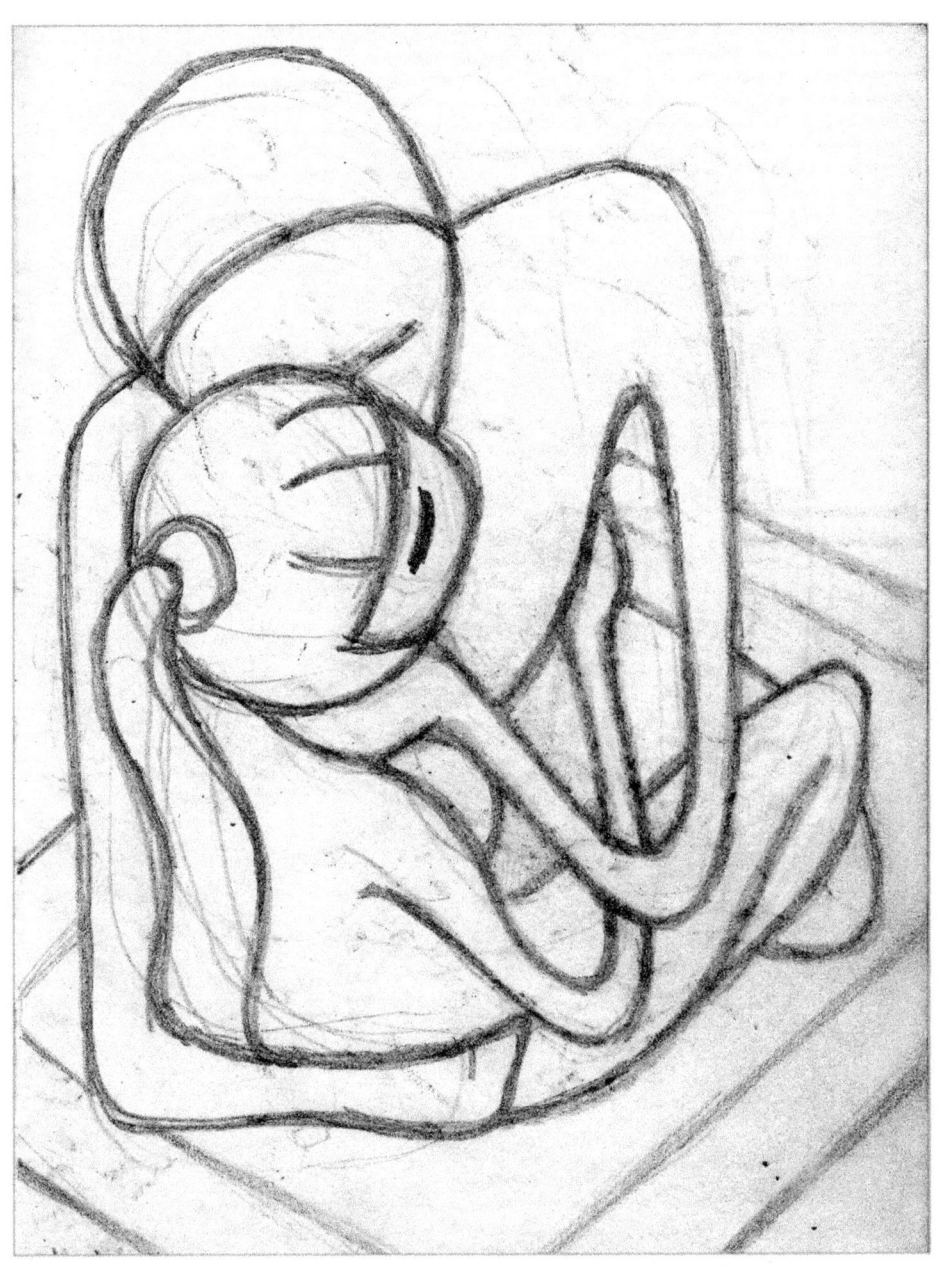

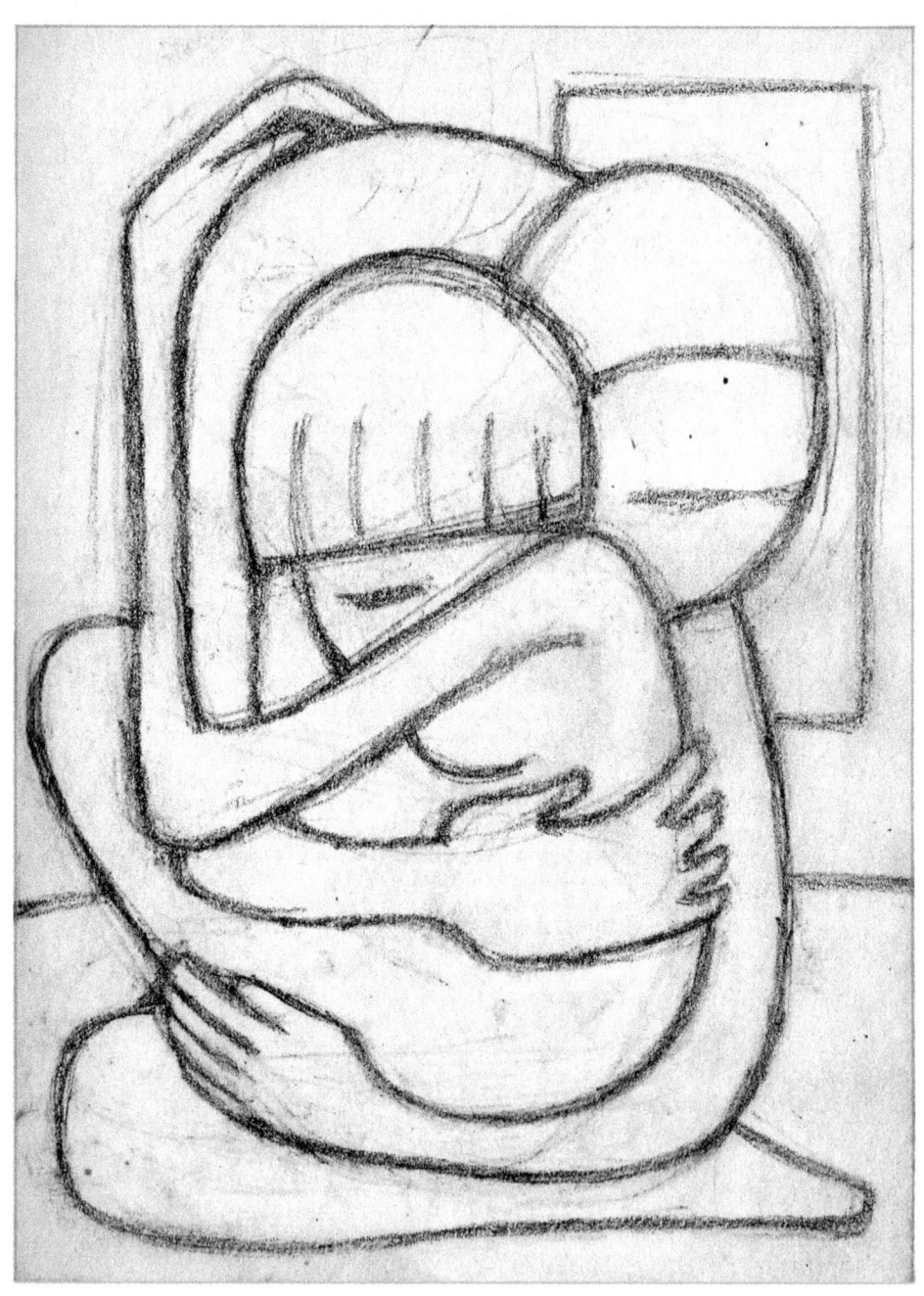

www.ingramcontent.com/pod-product-compliance
Lightning Source LLC
Chambersburg PA
CBHW072304170526
45158CB00003BA/1184